ROME
ETERNAL CITY
PHOTOGRAPHIC GUIDE

Curated by

Emma Mafalda Montella

MAGNUS EDIZIONI

ROME ETERNAL CITY
PHOTOGRAPHIC GUIDE

MAGNUS EDIZIONI
© Magnus Edizioni 2024

Curated by
Emma Mafalda Montella

Editorial director
Federico Ferrari

Editing
Laura Lopardo, Asia Graziano

Layout
Gianni Grandi, Roberta Vargiu

Photo credits:
© iStock.com: Deniz Unlusu: *4*. MasterLu: *5, 70*. Fabrizio Troiano: *6, 13*. Sjhaytov: *6*. Sazonof: *6*. Photo Beto: *7, 8, 22, 24, 3, 89, 92, 12*. Phooey: *8-9*. Samuel Howell: *11*. Leochen66: *12*. Yves Grau: *12*. Neirfy: *14*. Jk78: *14*. Martin Hosmart: *14*. Vladislav Zolotov: *14, 45, 60, 94, 103*. Eloi Omella: *15*. E55evu: *16, 22, 67*. Adisa: *17*. Anya Ivanova: *17*. Asergieiev: *18*. Gollykim: *18*. Fotokris: *20*. Syhaytov: *22, 52, 73*. Perseomed: *23*. Julius Fielder: *25, 86*. Keff Banke: *32*. Fabiomax: *33*. SvetlanaSF: *33*. Massimo Merlini: *42, 76, 77*. Nikada: *42*. Grafxart8888: *42*. Nicola Forenza: *43, 60*. Anna Pakutina: *46*. Mikeinlondon: *48*. Tshka: *51*. Phant: *52, 70*. Bernard Bialorucki: *52, 54*. Tunart: *52, 56*. Pedro Emanuel Pereira: *54*. Judith Engbers: *57*. Maui01: *60*. Benedek: *63*. Photooiasson: *67*. Oleg Albinsky: *70, 78*. Noel Mallia: *71*. Frederic Prochasson: *72*. Romaoslo: *76, 86, 118*. Creativepictures: *78*. Luca Mato: *78*. Artur Bogacki: *78*. Naumoid: *79, 94*. Sedmak: *80-81, 98*. We-Ge: *81*. Starryvoyage: *82*. ZU_09: *83*. Kevin Miller: *84*. Eli Frassens: *85*. Walencienne: *86*. BRCHphoto: *86*. MoT: *86*. LedLopezHdz: *87*. Stockphoto52: *90*. Frankix: *90*. Rarrarorro: *91*. Borisb17: *92*. Arogant: *92*. Elxeneize: *93*. TravelFlow: *95*. Emicristea: *95*. Onairda: *96*. Trotalo: *97*. George Oprea: *97*. Caroline Brundle Bugge: *99*. VvoeVale: *100*. Gun75: *100*. StazonovPhoto: *100*. Boryak: *100*. NYPhotoboy: *103*. Francesco Cantone: *109*. Massmedia: *111*. Marco Piunti: *111*. Harald Pizzinini: *112*. Valerio Mei: *112, 118, 119, 120*. Franco Tognarini: *112, 118*. Diego Fiore: *113*. Rimbalzino: *115*. Gabriele Gelsi: *116*. Fabianodp: *118, 123*. Misterbike: *120*. Cavallapazza: *120*. Paolo Gaetano: *125*. Wjarek: *125*.
© Emma Mafalda Montella: *6, 9, 28, 55, 65, 68, 111, 115, 116, 119, 122, 124*.
Courtesy of © Studio Cassio - Arte del Mosaico: *8*.
Photo © Andrea Jemolo / Bridgeman Images: *7, 10, 64-65, 68, 108*.
© Magnus Archive: *14, 20, 30, 34, 35, 44, 46, 48, 49, 51, 53, 55, 56, 58, 65, 80, 81, 96, 102, 104, 106, 107, 114, 117*.
Luisa Ricciarini / Bridgeman Images: *15, 35, 50, 74*.
© Ashmolean Museum / Bridgeman Images: *19*.
© Magnus Archive / H. Simeone Huber: *21, 30, 54-55, 58, 62*.
© Bridgeman Images: *2, 29, 32, 34, 41, 75, 77, 92, 102, 105, 107, 110*.
© Magnus Archive / Massimo Listri: *26, 27, 28, 42, 47, 59, 60, 66, 69, 75, 88, 98-99, 101, 105*.
© Copyright Universal Images Group / Bridgeman Images: *42*.
Photo © Stefano Baldini / Bridgeman Images: *75*.
AGF / Bridgeman Images: *116*.

Photo © Governatorato dello S.C.V – Direzione dei Musei. All rights reserved:
Raphael's Rooms: *22, 36, 37, 38*. The Sistine Chapel: *30, 39, 40, 41*. Vatican Gardens: *118, 121, 122*.

Photo campaigns made by Scripta Maneant – Carlo Vannini, Ghigo Roli, BAMSphoto. Production manager Gianni Grandi.
All photographs are the property of Governatorato dello S.C.V. - Direzione dei Musei and protected by copyright (© Governatorato dello S.C.V – Direzione dei Musei. Tutti i diritti riservati).

SM SCRIPTA MANEVNT Group

ScriptaManeant • Impronta d'Artista • Magnus Edizioni

© Scripta Maneant Group 2024
Via dell'Arcoveggio, 74/2
40129 - Bologna - Italy
Tel. +39 051 223535
Numero verde 800 144 944
www.scriptamaneant.it
segreteria@scriptamaneant.it

The Magnus Edizioni brand is owned by Scripta Maneant Group, Bologna, Italy,
All rights of reproduction, in whole or in part, of the text or the illustrations, are reserved throughout the world.

ISBN: 978-88-7057-291-9

Index

What you'll find in these pages	4

1 Monti — 7
- Church of Santa Maria ai Monti — 9
- Square of Madonna dei Monti — 11
- Basilica of Saint Peter in Chains — 11
- Papal Basilica of Santa Maria Maggiore — 13
- Villa Aldobrandini — 13

2 From the Imperial Forums to Saint John Lateran — 15
- The Arch of Costantine — 18
- Domus Aurea — 19
- Basilica of Saint John Lateran — 20

3 Trastevere — 23
- The Fountain of Acqua Paola and the Botanic Garden — 24
- Villa Farnesina and Galleria Corsini — 25
- Ancient Pharmacy of Santa Maria della Scala — 26

4 Vatican City — 31
- Saint Peter's Basilica — 33
- The Vatican Museums — 36
- Raphael's Rooms — 37
- The Sistine Chapel — 39
- Museo Pio Clementino — 41
- Museo Chiaramonti — 41
- The Egyptian Gregorian Museum and the Etruscan Gregorian Museum — 41

5 From Termini to Piazza Venezia — 43
- Roman National Museum of Palazzo Massimo — 43
- Baths of Diocletian, Basilica of Santa Maria degli Angeli e dei Martiri and Museum of the Rescued Art — 43
- The Fountain of the Moses and the Church of Santa Maria della Vittoria — 45
- Palazzo delle Esposizioni and the Church of San Carlo alle Quattro Fontane — 45
- Piazza del Quirinale, Palazzo del Quirinale and the Scuderie del Quirinale — 46
- Palazzo Colonna, Trajan's Markets and Trajan's Column — 48
- Vittoriano and Palazzo Venezia — 48
- Capitol Hill — 49
- Church of Santa Maria in Aracoeli — 51

6 From Castel Sant'Angelo to Piazza di Spagna — 53
- Castel Sant'Angelo — 53
- Piazza di Spagna — 56

7 From Piazza Navona to Campo de' Fiori — 61
- Piazza Navona — 61
- Chiostro del Bramante and Church of Santa Maria della Pace — 64
- Church of Sant'Ivo alla Sapienza and State Archive — 65
- Palazzo Farnese — 66
- Galleria Spada — 66
- Campo de' Fiori — 67
- Palazzo Braschi — 68

8 From Piazza Barberini to Villa Borghese — 71
- Trevi Fountain — 71
- Palazzo Barberini — 73
- Piazza Barberini — 75

9 Largo di Torre Argentina and Pantheon — 79
- Pantheon — 81

10 Jewish Ghetto — 87
- Piazza Mattei — 87
- Jewish Ghetto — 88
- Tiber Island — 91

11 From Teatro Marcello to Giardino degli Aranci — 93
- Teatro Marcello — 93
- Circus Maximus — 95
- Il Giardino degli Aranci — 97

12 From Piazza del Popolo to Villa Borghese — 101
- Piazza del Popolo — 101
- Villa Borghese — 103
- National Etruscan Museum of Villa Giulia — 106
- National Gallery of Modern Art — 107

13 San Lorenzo — 109

14 Walks in Southern Rome — 113
- Park of the Aqueducts — 113
- Ancient Appian Way — 115

15 Parks and Fountains in Rome — 119
- The parks of Rome — 119
- Rome and the water — 122

Index of Places — 126

What you'll find in these pages

Facing: Sunset over Rome.

Below: Trevi Fountain, statue of Oceano.

All roads lead to Rome.

This proverb of medieval origin, widespread throughout the world recalls the importance of Rome in antiquity as the nerve center of political, social, cultural and power dynamics.

It is no coincidence that since remote times one of the epithets of the city has been *Caput Mundi*.

An exception to every other European capital, Rome is where the modern perfectly blends with the ancient and every construction and excavation overlaps with other buildings.

This historical continuity is part of its charm: from a great city of the ancient world that hosted events of global significance, Rome went on to being the modern city that it is today.

Contradictory in many ways, Rome is the story of a *universum* that oozes history from every corner. The name itself is so ancient that its origins are not well known. Some claim it derives from Romulus and the legendary founding of the city (753 BC), others from the Etruscan 'rumon' (river), or the Oscan 'ruma' (hill). Filled with past glory, the *Urbe* is constantly evolving, keeping track of each event as if it was a scar. Recalling the words of Goethe, in Rome *everything is as it was imagined, and everything is new*.

Amongst the many symbols that represent it are the Lupa, the Colosseum, the Imperial Eagle, the Trevi Fountain and the dome of St. Peter's Basilica. An underground labyrinth of rivers and springs makes its way through the ancient foundations, feeding the entire city with water.

Roman aqueducts are now the bearing walls of houses, ancient ruins have become the foundations of other buildings and some temples have been converted into churches. After two thousand seven hundred years, Rome still stands, overlooking the Tiber with the melancholic charm of its ruins, preserving the highest concentration of historical, archaeological, and architectural heritage worldwide, with more than 16% of the world's cultural heritage and 70% of Italy's.

Some say that "one lifetime is not enough to really know Rome", and it'll take a while for anyone to get to know the city and learn how to dialogue with it.

It is therefore difficult to write a guide on Rome whose purpose is not only to provide information on a monument, but also to convey the history and uniqueness of the place. Rome is not a city of order or symmetry, and one of the most internationally famous saying is "when in Rome, do as the Romans do", which refers to the importance of adapting and following the traditions of the places one visits. This edition,

structured in fifteen chapters, proposes **fifteen different itineraries** that mainly concern the historical centre of Rome covering squares, palaces and monuments, giving the visitor the opportunity to observe how these places have changed over the centuries. These fifteen itineraries will make it easier to plan a visit, as they highlight different central areas, ensuring that closer places communicate with each other. The fifteenth chapter is then an in-depth look at Rome's parks and fountains and illustrates some of the city's green areas, explaining the long relationship between the Urbe and its waterways.

Ultimately, the various sections are enriched with **small Fun-facts, Ambience and Pit stops boxes**, which will offer an alternative view of the sights. The first ones are actual fun-facts related to the places you will visit, whereas the second are small additional information that relate to the nearby attractions or those already mentioned in the text, while the Pit stops boxes are food suggestions that will sweeten your visit. The book also includes **digital content that can be accessed via QR codes**, divided into two categories. The first concerns in-depth information on places already mentioned in the text, while the second proposes additional attractions that, although not mentioned in the text, can be visited along the way. These places of interest are marked on the map at the beginning of each chapter with a special icon, so that you know where they are and can better plan your walk. These are itineraries I've walked many times when I was living in Rome, and it makes me very happy to be able to share the magic of these places I used to see every day. Throughout this guide I've tried to convey the emotions that I felt when, late at night, I used to run to catch the last subway passing from Spagna (which I've incredibly never missed). In those rushes there has never been a time when I was able to resist the temptation to stop and admire the scenic beauty of the completely empty Piazza di Spagna, immersed in darkness, illuminated at times by its elegant lamp posts placed at the edges of the staircase and with the insistent roar of the Barcaccia water in the background.

Long walks in the Parco degli Acquedotti at sunset defeated all my sadness.
Rome is the place where you can breathe the dust of past centuries filling the air and the soul of its wanderers.

Legend of symbols

- Church / Basilica
- Museum / Palazzo
- Monument / Archeology
- View / To photograph
- To see
- Park / Garden

Fun-fact
Find out more, between history and legend

Ambience
To experience the city through suggestions and emotions

Pit stop
Tasteful breaks in historic and unmissable places

Scan the QR code at the beginning of each itinerary to access extra content and useful links

Map

Barberini Ⓜ

Repubblica Ⓜ

Termini Ⓜ

Roma Termini

Palazzetto Borgia Monti and the Staircase of the Borgia

1.4 Papal Basilica of Santa Maria Maggiore

1.5 Villa Aldobrandini

1.1 Church of Santa Maria ai Monti

1.2 Square of Madonna dei Monti

Forum of Nerva

Villa Pallavicini-Rospigliosi and the Aurora by Guido Reni

1.3 Basilica of Saint Peter in Chains

Vittorio Emanuele Ⓜ

Parco Del Colle Oppio

Colosseo Ⓜ

Monti

Monti is one of the first districts of Rome and its name comes from the word mountains, after the hills that surround the city: the Esquiline, the Viminal, part of the Quirinal and the Caelian Hills. Originally known as an infamous place called *Suburra* (literally "slum"), Monti is now a well-known touristic area in Rome. The *Suburra* was divided into two main parts, one that stood below the Imperial Fora level, which was overcrowded and poor, and an upper part, much more exclusive, close to the Baths of Diocletian. The latter was occupied by villas (*domus*) where wealthy patricians lived. It was right in one of these *domus* that Julius Caesar was born in 101 B.C.

One of the main avenues of the lower part of *the Suburra* was called the *Argiletum* (the Clay Avenue), which today coincides with Via Leonina and Madonna dei Monti, as the entire area was swampy due to the amount of rainwater that merged coming from the hills nearby making the air unhealthy.

The area was then drained out thanks to the *Cloaca Maxima*, one of the world's earliest sewage systems, commissioned by Lucius Tarquinius Superbus, the last king of Rome. The *Cloaca Maxima* was completed by the end of the sixth century B.C. and was supposed to drain the entire area surrounding the Imperial Fora, Circus Maximus and the *Suburra* by channelling surface waters into drainage pipes.

In order to aid the economic recovery of the area, in the fourteenth century

Above: Architectural complex part of the *Tomb of Julius II*, Michelangelo Buonarroti, Basilica of Saint Peter in Chains, 1505-1545.

Below: Decorative relief, detail from the *Tomb of Julius II*.

pope Nicholas V allowed artisans and small businesses to be exempted from paying taxes, turning it into what we refer as a "free trade zone". The situation changed during the Middle Ages when the roman pipelines were out of function and the inhabitants moved to the nearby Campo Marzio. Up until the beginning of the nineteenth century Monti was a green area, with many gardens and scarcely populated due to its long distance from the Tiber, although it remained a crossing point for pilgrims on their way to the Cathedral of Saint John Lateran or the Papal Basilica of Santa Maria Maggiore.

Today Monti is a fascinating and picturesque neighbourhood, full of bars and vintage shops like the Blue Goose and Pifebo. Historically known for its artisanal boutiques, in Monti you'll find many small businesses specialised in the arts and crafts like jewellery or watchmaking. If you're in need of repairing an old family watch, Orologeria Verdastro is the right place for you! The store has been making and repairing watches for generations and can bring back to life old heirlooms.

Another interesting laboratory is Studio Cassio in Via Urbana, which specialises in micro mosaic, a special roman technique, and it collaborates with the Vatican Mosaic Study, in order to restore the Vatican mosaics. The place also hosts many formative courses on mosaic art and has recently put in stock plastic pieces, each one conceived with one single plastic bottle, which can be used to realise wall mosaics. A very smart way to make mosaics green and sustainable!

CHURCH OF SANTA MARIA AI MONTI

Also known as Madonna dei Monti or **Santa Maria ai Monti** > 1.1, the Church can be found in Via dei Serpenti, and its name may come from a picture depicting the Virgin stepping on a snake which was hanged on a wall in the lane. Santa Maria ai Monti is richly decorated with marbles, plasters and frescoes painted by Giacinto Gimignani, Orazio Gentileschi, Antonio Viviani, Lattanzio Mainardi and Paris Nogari. The church's construction was commissioned in 1580 by Pope Gregory XIII to Giacomo della Porta, in a place where previously stood an ancient monastery of the Poor Clares sisters' congregation. The sober façade of the building is inspired by the Church of the Gesù, the mother church of the Society of Jesus, and is the second church of the Jesuits present in Rome.

Facing, on the top: Romanesque-style Bell tower that belongs to the Papal Basilica of Santa Maria Maggiore, 1445-1483, 75 metres high.

Facing, below: Polychrome mosaic depicting the figure of a Gorgoneion. Replica by Studio Cassio. The original one is kept in the Roman National Museum of Palazzo Massimo.

At the centre: Interior of the Papal Basilica of Santa Maria Maggiore. The structure is original of the fifth century, but has undergone several changes and renovations over time.

Above: View on the Church of Santa Maria ai Monti, 16th century.

On the following page: Mosè, Michelangelo Buonarroti, marble, Basilica of Saint Peter in Chains, 1513-1516.

Above: The reliquary with the chains of Saint Peter.

SQUARE OF MADONNA DEI MONTI

Positioned amongst Via dei Serpenti and Via degli Zingari, the **Square of Madonna dei Monti** > 1.2, carries the same name as the church standing in front of it. Right at the centre of the square there's the beautiful octagonal shaped fountain of the Catecumeni, made of travertine and commissioned by Pope Sixtus V to Giacomo della Porta in 1588. The charming fountain represents one of the nerve centres of the social life in Monti and around night-time young people fill it up, sitting on the fountain steps with a drink in their hands.
Right next to the square there's Via degli Zingari, named after the nomad settlements that established in the area during the seventeenth century. Today on one of the street palaces walls there's a commemorative marble slab placed by the Municipality of Rome in 2001, in memory of all the nomad populations killed in extermination camps in World War II.

BASILICA OF SAINT PETER IN CHAINS

The Basilica is located on the Oppian Hill > 1.3, one of the three spurs of the Esquiline Hill, and was built in the fifth century close to the Baths of Titus. It was commissioned by the Roman empress Licina Eudoxia, who went down in history for being the one who invited the Vandals that sacked Rome in 455. The church also goes by the name Eudoxian Basilica and hosts the funeral monument of Pope Julius II (who's buried in Saint Peter's Basilica), designed by Michelangelo Buonarroti. The project took a long time to finish (almost forty years) because the pope lost interest over the years and the artist designed many different versions of the monument. The one we see today is the final one, much reduced than the original project. Right at the centre

AMBIENCE

Walking down **Via degli Zingari** you'll find many small bars where you can sit outside and get a glass of wine, enjoying the fascinating atmosphere of the city. Many bistros in the area are also art galleries or libraries: that's what makes the place even more magical.

PIT STOP

Right on the corner of the two streets there's a fascinating cactus, climbing on the palaces' walls to reach the sunrays, while opposite there's a sandwich place called Zia Rosetta which serves the most delicious "rosette", a typical Italian rose shaped bread. There's a wide selection of rosette, (the place is also vegan friendly) which you can buy to go and eat in the park of **Villa Aldobrandini**!

of the compound there's the monumental statue of the *Moses* (235 cm tall), carved by Michelangelo in 1513. The statue is a dominant element within the composition, and it represents the moment right after the delivery of the commandments on the Sinai Mount, when *Moses* finds the Israelites worshipping a golden calf, a symbol of pagan religions. The prophet is therefore represented in the exact moment when he's about to explode full of wrath; his veins are pulsing, and the muscles in tension are shining through the marble. The artist gave the statue two horns on its head, following the description of the passage found at chapter 34 of the *Exodus*. The horns were much discussed throughout history, because apparently, they come from an incorrect translation from Hebrew. In fact, the idea stems from the mistranslation of the word "karan" (rays) with "keren" (horns) in the passage where Moses appears coming down from mount Sinai with shining sunrays on his head. The artist was probably aware of the mistranslation and decided to give the statue a pair of horns regardless.

The Basilica is also known for preserving the chains of Saint Peters. Tradition has it that the chains were used when the Saint was a prisoner in Jerusalem and afterwards in the Mamertine Prison. The relics are kept on display inside a marble altar, closed by two bronze gold gilded doors, executed by Giovanni Matteo Foppa in 1477.

PAPAL BASILICA OF SANTA MARIA MAGGIORE

The monumental church > 1.4 is one of the four major basilicas in Rome, and it's located on the Esquiline Hill. Its construction was commissioned by pope Pope Sixtus III in 434 and the church stands on the exact location where, legend has it, miraculously snowed during the summer of 358. Since then, Mary is celebrated every year on the fifth of August, with a pompous light show in the Square and, during the mass, with a cascade of white rose petals from the ceiling of the Basilica. The structure of the Basilica is the original one from the fifth century and in the Square there's a massive column that comes from the Basilica of Maxentius in the Trajan Forum. The bell tower is 75 metres high and is the tallest one in Rome. Inside the church is richly decorated with its fifth century and thirteenth century mosaics that adorn the loggia, the cosmatesque pavement and the frescoes like the one on the apse depicting *The Coronation of the Virgin* by Jacopo Torriti.

Amongst the sacred relics kept in the altar (a porphyry sarcophagus) we can find the ones that belonged to Saint Matthias and Saint Jerome, while right on the right of the altar there's a marble slab which commemorates the death of the architect Gian Lorenzo Bernini who died in 1680 and of his father Pietro. The Basilica also includes the famous Sforza Chapel, realised following Michelangelo Buonarroti's project, the Cesi Chapel, designed by Guidetto Guidetti and Giacomo della Porta, and the Chapels Paoline and Sistine. The Basilica also houses the Nativity by Arnolfo di Cambio, the relic of the Holy Cradle and the icon of the *Salus Populi Romani*.

VILLA ALDOBRANDINI

The main entrance to the park > 1.5 of the villa is hidden on the northern side of the wall perimeter, which makes the park isolated and not very well known to the tourists who often mistake it for being private. The park looks unkept, with its beheaded statues and ruins of roman columns laying around, making it even more fascinating. The sixteenth-century villa is closed to the public and it now belongs to the *International Institute for the Unification of Private Law*, while its garden was turned into a public one when it was donated to the Municipality of Rome and reopened in 2016. The park is now open every day from 7 am to 18 pm.

You'll enjoy a great view on the Church of Sant'Agata dei Goti and on the one of Santa Caterina in Magnanapoli, amongst the shade of the palm trees. The view is especially gorgeous at sunset! From the high walls of the park, you'll catch a glimpse of the Tower of Milizie, which is now part of the Trajan Markets archaeological site and was built in 1348. It was one of the highest mediaeval towers in the city (it measured 51 metres), but it collapsed not long after its construction due to a terrible earthquake that shook Rome. The tower was abandoned and it now hangs to one side.

Above: Gardens of Villa Aldobrandini.

Facing, on the top: View of the central nave, Papal Basilica of Santa Maria Maggiore.

Facing, below: Detail of the cosmatesque floor in the Papal Basilica Santa Maria Maggiore.

PIT STOP

If you're looking for a "sweet escape" while walking around Monti, we recommend going to *Regoli's* bakery, famous for its "maritozzi" (a typical roman dessert). The place is usually crowded, and it often runs out of maritozzi by lunch time, but it's definitely worth a try! On the same street stands **Palazzo Merulana**, a beautiful historical building, now a museum where you can admire works of the Italian 20th century.

Barberini Ⓜ

Cavour Ⓜ

Vittorio Emanuele Ⓜ

- 2.2 Capitol Hill
- 2.1 Imperial Forums

Colosseo Ⓜ

- 2.5 Domus Aurea
- Parco Del Colle Oppio
- 2.3 Colosseum
- 2.4 Arch of Costantine
- The Basilica of Saint Clement
- The monastery and the Basilica of the Four Crowned Martyrs
- 2.6 Archbasilica of Saint John Lateran

Circo Massimo Ⓜ

From the Imperial Forums to Saint John Lateran

Above: View of the Colosseum.

Below: Bust of emperor Tito Flavio Vespasiano, Capitoline Museums, 9-79 B.C.

Via dei Fori Imperiali > 2.1 is right next to the **Capitol Hill** > 2.2 and was opened to the public on the 21 of April 1933, when, in order to create the avenue and unearth the ancient roman ruins, the entire area between the Alessandrino Quarter, the Colosseum and Piazza Venezia was demolished and with it its mediaeval and renaissance palazzos. The urban structure of the city centre was altered during fascism, to prioritise the Roman ruins and to glorify them. Although today the area is one of the most important archaeological sites in the world, the destructive operation was the object of many discussions during the twentieth century.
Via dei Fori Imperiali owes its name to the ancient roman fora that were brought back to light. The first one was built by Julius Caesar in 54 B.C., followed by the one of Augustus (31 B.C.), of Vespasian (71-75 A.D.), of Nerva (98 A.D), and finally the Trajan Forum (107-113 A.D.). Entirely dedicated to public life, the fora were built at the end of the Republican age. Overlooking the end of the avenue is also the massive Basilica of Maxentius, built at the beginning of the fourth century A.D. on the Velian Hill, the Basilica will be an example for many architects during the Renaissance. Via dei Fori Imperiali is full of life with its street musicians, and at night light effects and projections animate the Imperial Fora, making the atmos-

Above: Basilica of Maxentius, beginning of the 4th century.

Facing, on the top: View inside the Colosseum.

Facing, below: Temple of Saturn, Roman Forum, 497 B.C.

FUN-FACT

There are four entries to the Colosseum which are aligned to the cardinal points. Two of them were reserved to the authorities, the vestals and to the emperor himself and led to the stands, whereas the other two doors directly faced the combat area in the arena. The latter were called respectively **"The Gate of Life"** and **"The Gate of Death"**. The first one was used as the entrance door for gladiators and, in case of victory, as their triumphal exit, whereas the Gate of Death was where the lifeless bodies of men and animals would go through once the spectacle was over. The two entries have been the subject of various popular tales and superstitions over the years. In the Middle Ages it was said that the Colosseum had a door that led directly to the underworld and at sunset the souls of those who died prematurely wondered around looking for eternal peace.

phere magical. The avenue leads to the Colosseum, symbol of the eternity of Rome, and is the biggest monument known to have survived since antiquity. Its perimeter measures 527 metres and the inner arenas' width is 86 per 54 metres with a 3.357 m² surface. The name "Colosseum" was given to the amphitheatre in the Middle Ages, and it comes from the colossal statue of the emperor Nero that was found nearby. The **Colosseum** > 2.3 was the first permanent amphitheatre of Rome, and its construction was commissioned by Vespasian right in the area where once was the artificial lake of the *Domus Aurea*. The monument was inaugurated by emperor Titus in 80 A.D. with public games that they say to have lasted for more than a hundred days and went from gladiator combats to the reproduction of battles.

The amphitheatre was then reused as a fortress during the Middle Ages and was left to the Senate and Roman population only in 1312. During the past centuries the monument has been ripped from its precious marbles and was used as a quarry for building materials. Important buildings such as Palazzo Barberini and Saint Peter's Basilica itself were built using marble that came from the Colosseum's façade. It was only in 1750 that Pope Benedict XIV decided to consecrate the Colosseum to the Passion of Christ, endorsing the idea that the monument was a sacred site, and forbade the use of the structure as a quarry.

The Colosseum has an elliptical shape and its façade made from travertine marble is 48 metres tall and divided in 80 arch-

es with Doric, Ionic and Corinthian semi columns. The monument was built in the western area of the Roman Forum which is now part of the Archaeological Park of the Colosseum.
The entire archaeological area of the Roman Forum which includes the Colosseum is enclosed between the Palatine Hill, the Capitol Hill and Via dei Fori Imperiali and for centuries was the nerve centre of the entire roman civilisation from the Regal period to the Middle Ages. It hosted important political, cultural, juridical and philosophical institutions which laid the foundation for part of the western culture.
Originally, the area was swampy but was then drained by the end of the seventh century B.C. and continued to be at the very centre of public life for more than a millennium. Aside from important monuments commissioned by the emperors like the Temple of Vespasian and Titus and that of Antoninus Pius and Faustina, in the Forum there's many other monuments dedicated to public, commercial, and political activities. After 608 B.C., when the Foca Column was erected, the Fora were set underground in the Middle Ages and became a green area where animals would graze known as the *Campo Vaccino*. Some of the ancient monuments kept living because they were converted into churches, like the well-known *Curia Iulia*, which became the Church of Saint Adrian al Foro, and the temple of Antonino and Faustina, now Church of Saint Lorenzo in Miranda, while the temple of Romulus turned into the Church of the Saints Cosma and Damiano.

To be remembered is also the famous Mamertine Prison, commissioned by the fourth king of Rome Ancus Marcius, where Catiline, Vercingetorix and possibly Saint Peter were kept as prisoners.

THE ARCH OF COSTANTINE

The Arch of Costantine > 2.4 stands right next to the Colosseum, right at the end of Via di San Gregorio. It's one of the biggest and best-preserved triumphal arches amongst the ancient roman ones; the others are the arch of Titus (81-90) and that of Septimius Severus (312). Commissioned by the senate, the arch was erected in 315 A.D. to commemorate the emperor ten years after his death. The monument also celebrates the victory of the emperor over Maxentius in the Battle of the Milvian Bridge in 315 A.D. In the Middle Ages the arch was converted into a fortress by the Frangipane family and was only "freed" in 1804, after its renovation.

The 25 metres tall arch was erected between the Palatine Hill and the Caelian Hill on the old Via dei Trionfi or Via di San Gregorio, and it embodies the passage between classical and mediaeval art. In fact, the arch was built re-using parts taken from other monuments, and most of the

Facing, on the left: Decorative reliefs from the time of Marcus Aurelius, southern façade of the arch of Constantine.

Facing, on the right: Triumphal arch of Constantine, 130-138 A.D.

On the left: Lucina presents little Adonis to the goddess Venus, fresco detached from the *Domus Aurea*, Ashmolean Museum, Oxford.

Above: Detail of the goddess Venus, fresco detached from the *Domus Aurea*, Ashmolean Museum, Oxford.

material comes from Trajan, Adrian, and Aurelian decorations. The emperors depicted in the reliefs have been reshaped on the resemblance of Constantine and the foundations of the arch were built using the wall structure of the *Domus Aurea* as their basis.

DOMUS AUREA

The remains of the ancient residence > 2.5 are now part of the Archaeological Park of the Colosseum, on the Oppian Hill, close to the Trajan Baths. The construction of the villa was begun by the emperor Nero in 64 A.D., right after the brutal fire that destroyed the city, wiping out part of the centre. This new residency was supposed to be remembered for its luxury and magnificence and was therefore called the *Domus Aurea* ("golden villa"). Designed and decorated by famous architects from the time, the urban manor was articulated in many small buildings and green areas, which inspired emperor Hadrian for the construction of his villa in Tivoli. The *Domus* included various gardens, forests, vineyards, thermal baths and even an artificial lake which stood right where the Colosseum is today.

After the emperor's death he was condemned to the *damnatio memoriae*, the full erasure of the subject from the historical record. Consequently, the *Domus* was partly destroyed and buried underground, and its walls were used as the support for other buildings such as the Trajan baths. In a decade the villa was plundered of all its precious materials and the artificial lake was drained by Vespasian.

Some of the structures on the Oppian Hill buried underground were uncovered during the Renaissance and are now visitable. The halls that are open to the public

FUN-FACT

During World War II, in order to protect the monuments from possible bombings, some of them were covered. The arch of Constantine, along with that of Titus and Septimius Severus, was wrapped in aluminium and cloth, and packed with sandbags that would protect it from the splinters. Statues were also protected the same way, including the Marco Aurelio statue at the very centre of the Capitolium square.

Above: Cosmatesque cloister of Saint John Lateran.

Below: Christ the Saviour in between multicoloured clouds, Detail of the mosaic on the apse of Saint John Lateran.

Facing, on the top: View on the central nave of the Basilica of Saint John Lateran.

Facing, below: Paleochristian baptistery, San Giovanni in Fonte al Laterano, 4th century.

are only a small part of the majestic complex that once belonged to the villa, which has inspired many architects and artists from the fifteenth century on, including Raphael.

BASILICA OF SAINT JOHN LATERAN

Not far from the Colosseum **the basilica** > **2.6** stands at the very end of Via di San Giovanni in Laterano, the artery constructed by Sixtus V in 1588 as one of the three main axes that connected the Lateran Basilica to the centre. The project was left unfinished but was supposed to connect the church to Saint Peters and to the Capitolium.

Saint John Lateran was founded by the emperor Constantine in the fourth century A.D. and was rebuilt several times during the past centuries. The roman cathedral serves as the seat of the bishop of Rome, the pope, and its shape as we see it today wasn't completed until the seventeenth century, after the façade renovations. Defined as "mother of all the churches worldwide" the basilica was initially erected for public meetings and for justice administration, but with the spread of Catholicism it turned into the majestic structure that we see today. Constantine commissioned its construction in 314 A.D. on the lands that belonged to the family of the Laterani, hence the name, and was consecrated in 324 from Pope Silvester the first. The basilica has been the protagonist of many historical events and was restored and damaged many times from the vandals of Genseric that looted it in 455, to the papal reconstructions of Leo III

and Bonifacio VIII who commissioned the frescoes to Giotto and Cimabue. After the pope returned from Avignon in 1378, the entire Lateran complex was abandoned as the papal court moved to the Vatican.

The beautiful travertine façade with its porch topped by a central loggia was designed by Alessandro Galilei in 1735. The massive church stands out with its 15 statues that top the façade which can be easily spotted at a distance, representing Jesus, John Baptist, and John the Evangelist, and at the sides the 12 doctors of the church.

The inside of the basilica is equally majestic and mostly reflects the creative genius of Borromini, who worked on the reconstruction of the façade commissioned by Innocenzo X in 1646. The architect created 12 niches alongside the central navy, where he placed the statues of the apostles, whereas the funerary monuments are positioned on the outer aisle's pillars. The cosmatesque pavement of the central navy dates to the fifteenth century, and was completed during the pontificate of Martin V, who is buried in a bronze sepulchre in the underground wing of the basilica. The transept was renovated by Giacomo Della Porta, and there's several frescoes of Cavalier d'Arpino, while some parts of the apse date back to the original fourth century basilica.

Next to the church there's the Baptistry, which belongs to the Constantine era. Its octagonal shape dates back to the fourth century and the space inside it is surrounded by eight porphyry columns topped by an architrave, covered by eight white marble columns, while at the very centre stands the green basalt baptismal urn.

- 3.1 Church of Santa Maria in Trastevere
- 3.2 Church of Santa Cecilia in Trastevere
- 3.3 San Pietro in Montorio
- 3.4 Fountain of Acqua Paola
- 3.5 Gianicolo Terrace
- 3.6 Botanical Garden
- 3.7 Villa Farnesina
- 3.8 Galleria Corsini
- 3.9 Ancient Pharmacy of Santa Maria della Scala

The Collapsed bridge and the Palatine bridge

Above: View of Ponte Sisto.

Trastevere

Trastevere is one of the most fascinating and notorious neighbourhoods in the city. Best known for its bars, restaurants, and nightlife, Trastevere offers many cultural attractions as well. The name comes from the Latin *Trans Tiberim*, literally "beyond the Tiber", and was only urbanised by the end of the Republican era (509 B.C.), when jews and Syrians settled there along with sailors and fishermen. It was under Augustus that the area started to be considered as part of the city, becoming the fourteenth roman region. The district was originally poor and far from the city centre, until the construction of beautiful villas under the empire. Trastevere is also remembered as being the place where the first Christian churches were built, like the church of **Santa Maria in Trastevere** > 3.1. Known as one of the oldest churches in Rome, it was founded by Pope Callixtus in the third century. Its structure changed between the fourth and the twelfth century and some of the material used to build it came from other monuments (*spolia*), like the 22 granite columns with Ionic and Corinthian capitals that separate the nave from the aisles which were recovered from the ruins of the Baths of Caracalla. The complex was entirely restored between the sixteenth and the nineteenth century, and both the façade and the tower bell are dated to the Romanesque period. The nave preserves its original basilica plan, and the wooden ceiling was designed and decorated by Domenichino in 1617 when he painted the *Assumption of the Virgin*. The mosaic atop of the apse vault depicts the *Life of the Virgin* by Pietro Cavallini (1291), while the portico was realised by Carlo Fontana in 1702.

FUN-FACT

Facing Piazza Trilussa is the **Sisto Bridge**, built by Pope Sixtus on the ruins of an ancient roman bridge, the pons Aurelius (215 A.D.), which collapsed after a major flood of the Tiber in 792 and was afterwards called *Ruptus* (broken). In 1475 Sixtus IV had it rebuilt and today it's famous for its "eye" shape, with four side arches and a central pylon.

Another remarkable church is the **Basilica of Santa Cecilia in Trastevere** > **3.2**, built between the sixth and twelfth century in the exact point where they say the saint has been martyrized. The mediaeval structure has been altered during the past centuries, and the interior of the church is richly decorated with a black and white marble ciborium executed by Arnolfo di Cambio. Under the main altar there's Stefano Maderno's beautiful statue of Saint Cecilia, sculpted in 1600 right after the discovery of the saints relics just under the basement of the altar.

Another important church in the centre of Trastevere is that of **San Pietro in Montorio** > **3.3**, built in the ninth century and later rebuilt at the end of the fifteenth century. It was erected in the exact spot where, tradition has it, Saint Peter was crucified, and today the church belongs to the roman headquarters of the Royal Academy of Spain. The latter also owns the precious Tempietto del Bramante, also called **Tempietto di San Pietro in Montorio**, which stands right at the centre of one of the monastery's courts.

THE FOUNTAIN OF ACQUA PAOLA AND THE BOTANIC GARDEN

The charming fountain of **Acqua Paola** > **3.4** is right at the end of Via Garibaldi in a spot that escapes city noise. The monumental fountain is also accessible from the staircase at the end of Via di Porta San Pancrazio, and the atmosphere is

especially captivating at night if you're looking for a place to escape the busy streets of Trastevere. However, the fountain is open to the public during the day and you can walk inside the small corridor overlooking the pool of water. The monument, also known as the Gianicolo Fountain, was built on the Janiculum Hill, right where the Trajan aqueduct ended.

The Passeggiata del Gianicolo is the tree-lined avenue on the right side of the fountain, which will lead you directly to the famous **Gianicolo Terrace** > 3.5, one of the main known viewpoints in Rome. Right under the terrace there's the beautiful park of Villa Corsini, which hosts the **Botanical Garden of Rome** > 3.6. One of the biggest ones in Italy, the garden covers an area of almost 12 hectares on the slopes of the Janiculum and it boasts many botanical species like secular trees and a wide bamboo collection.

VILLA FARNESINA AND GALLERIA CORSINI

When we talk about the Roman Renaissance, we can't fail to mention **Villa Farnesina** > 3.7, one of the most beautiful manors in Rome. The villa is in Via della Lungara and today also hosts the headquarters of the National Academy of the Lincei. Built between 1506 and 1512, its construction was commissioned by the banker Agostino Chigi to the architect Baldassarre Peruzzi as his personal suburban villa.

We highly recommend paying a visit to the elegant halls of the villa decorated with frescoes by artists Baldassarre Peruzzi, Giulio Romano, il Sodoma, Sebastiano del Piombo and Raphael.

Each room has a different theme, such as the *Cupid and Psyche* loggia on the ground floor which depicts stories taken from classical mythology. Here, *The Triumph of Galatea*, shows a beautiful nymph standing on a shell-shaped chariot and the same loggia has a horoscope vault depicting all the planets of the patron's astral chart. The *salone*

Above: Fountain of Acqua Paola, also known as the Fontanone del Gianicolo, marble and granite, 17th century.

Facing, on the top: Tempietto di San Pietro in Montorio, Donato Bramante, 1510.

Facing, below: View on the Church of Santa Maria in Trastevere.

PIT STOP

In Piazza Trilussa there's an alternative place to the usual restaurants: the *Trapizzino*, famous for its sandwiches (but you'll also find a wide selection of roman specialties like the "supplì"), halfway between a pizza and a sandwich, filled inside with all sorts of delicious ingredients. Among the classic trapizzini we recommend the "Double Panna" for a good combo with anchovies and burrata. You can take the trapizzino to go and eat it sitting on the steps of the beautiful fountain of Ponte Sisto.

Above: Hall of the Perspectives, Baldassarre Peruzzi and Sebastiano del Piombo, fresco, Villa Farnesina, 1506-1511.

Facing: Loggia of Cupid and Psyche, Villa Farnesina, Raphael, 1506-1511.

PIT STOP

Da Enzo al 29 is one of the restaurants that you must try. Its impeccable reputation draws many tourists every day and the line to get in is usually quite long, but the Cacio e Pepe is definitely worth the wait!

painted by Peruzzi is also striking, with its *trompe-l'oeil* fresco, one of the first of its kind, anticipating the countryside view beyond the balcony, and the perspective from the fake colonnade is extremely precise. Another famous fresco is the one by Sodoma, who painted the life of Alexandre the Great in the adjoining bedroom on the upper floor.

The Galleria Corsini > 3.8 is right across the street from Villa Farnesina, and it hosts part of the Galleria Nazionale d'Arte Antica (along with Palazzo Barberini). The alluring gallery exhibits the works coming from the collection of the Corsini family who bought the palazzo in 1736. The building is also known for having hosted Christina, the Queen of Sweden, in the sixteenth century, who had it entirely renovated by the architect Ferdinando Fuga. Amongst the remarkable works of art exhibited in the gallery there's the *Saint John Baptist* by Caravaggio and the *Saint Sebastian* by Peter Paul Rubens.

ANCIENT PHARMACY OF SANTA MARIA DELLA SCALA

There's a famous story concerning the Church of Santa Maria della Scala and it involves the well-known Italian artist Michelangelo Merisi, also known as Caravaggio, to whom the church commissioned the painting *The Death of the Virgin*. The artist finished the canvas in 1606, but the painting was refused by the parish, as it was seen as "unfit" for the church, due to the scandalous position of the dead body of the Virgin. Her ankles and abdomen were swollen, and her body was not as idyllic as it should have been. The

painting was then rejected by the fathers of Santa Maria della Scala and replaced by a more conventional picture of the same subject by Carlo Saraceni (1579-1620). Today *The Death of the Virgin* is at the Louvre and is one of the most notorious paintings by the artist.

One thing many people don't know is that the very same church who refused Caravaggio's canvas has had a prosperous activity in running one of the most famous pharmacies in Rome. In fact, the **Ancient Pharmacy of Santa Maria della Scala > 3.9** has been the Pope's personal pharmacy from the sixteenth century until the twentieth. The religious order of the Discalced Carmelite was famous for its medications such as the "Acqua di Melissa", a Lemon Balm that was used as a soothing and calming cure, and the so called "Acqua della Scala", a lavender water used to heal colds. The Pharmacy's activity lasted for half a millennium and served many generations of Popes, closing its business in 1954 and has been replaced by the modern Pharmacy of Santa Maria della Scala, right below it. The old farmacy is a true gem, which you can visit only by sending an email to the Discalced Carmelite booking your visit. You'll find all the information on their website. During your visit you'll notice how the disposition of all the medicines in the glass ampoules on the shelves has remained unchanged since the 50s.

Above, on the left: St. Sebastian curated by the angels, Pieter Paul Rubens, oil on canvas, Galleria Corsini, 1601-1602.

Above, on the right: Death of the Virgin, Caravaggio, oil on canvas, Louvre Museum, 1604-1606.

Facing, on the top: One of the rooms of Palazzo Corsini, 15th century.

Facing, below on the left and on the right: The Ancient Pharmacy of Santa Maria della Scala, 17th century.

AMBIENCE

Found in the southern part of Trastevere, **Porta Portese** is one of the biggest flee markets in Rome, and it certainly is the most famous. If you're looking for something, spacing from books to clothes to *memorabilia*, odds are you'll probably find it here. The market is usually packed with people and the true seekers show up early in the morning to avoid the crowds. You'll find some tourists as well, but the place is filled with locals.

4.4 Vatican Museums

4.5 Sistine Chapel

4.3 Saint Peter's Basilica

4.2 Saint Peter's square

4.1 Via della Conciliazione

Cipro

Ottaviano

Vatican City

Walking down Via della Conciliazione > 4.1 you'll see the monumental Church of Saint Peter. The Vatican is the smallest state in the world both population and extension wise, and the "independent state" status was conferred to it in 1929 with the Lateran Treaty which regulated the relationship between the church and the state. Surrounded by walls the Vatican is an absolute monarchy whose official language is Italian, despite Latin being the official language of the Holy See. The Vatican has its own juridical system, its own currency, stamp, radio and even its own newspaper *The Roman Observatory*. The state is protected by the Swiss Guards but, since 1506 has its own police force, the Vatican police. Part of the territory's surface is occupied by the Vatican Museums whose access is on Viale Vaticano.

The Vatican City became the pope's official residence in the fourteenth century, right after the end of the exile in Avignon. Ever since, each pope gave his contribution to embellish and decorate the papal state throughout the centuries. Amongst the popes that were defined "patrons of the arts" was Sixtus IV, a theology professor who commissioned the construction of the Sistine Chapel, that takes after his name, and reallocated some of the ancient roman bronze statues on the Capitol Hill, such as the *Lupa capitolina*. Another pope who had a deep interest in the arts was Julius II who commissioned the reconstruction of Saint Peters façade to Donato Bramante.

Above: Saint Peter's square, detail of the colonnade and the dome.

On the following page, on the top: View on Saint Peter's square.

On the following page, below: Baldachin of Saint Peter, Gian Lorenzo Bernini, bronze, marble base, 1623-1634.

AMBIENCE

We strongly advise to visit the **Vatican Gardens**, along with the **train tour of the Ville Pontificie**. The tour is on every Saturday and the railway links the Vatican City to the pope's villa of Castel Gandolfo.

Saint Peter's square > **4.2** on the other hand was commissioned by pope Alexander VII to Gian Lorenzo Bernini, with specific instructions for it to be of great impact for the incoming visitors.

Bernini designed an oval shaped complex and articulated square, detached from the church's façade, with its own architectural structure that resembles two arms, those of Christianity, that metaphorically envelop the visitor with their massive Doric colonnades, four columns deep. The colonnade is made up of 284 large, unfluted columns and 88 pilasters. Right at the centre stands an Egyptian obelisk that was placed there by order of Pope Sixtus V. The 2000 years old obelisk was brought to Rome by Caligula and was only placed at the centre of Saint Peter's square in 1586.

The shape of the *piazza* creates a perfect perspective, and the simplicity of the colonnade emphasises the redundant façade of the basilica. There's a particular stone located on the square's pavement, right next to the obelisk, and if you step on it, you'll be able to see the colonnade as a single row of columns. An anecdote that proves the meticulous attention of its architect.

The wide boulevard that leads to the piazza is called Via della Conciliazione and its construction is quite recent. Built between 1936 and 1950, the avenue has been at the centre of many discussions throughout the years; in fact, to make space for the avenue, a huge part of the neighbourhood of *Borgo* was demolished. The old mediaeval

area was believed to be too complicated for the pilgrims and the visitors to cross in order to reach the Vatican, due to its narrow and tangled streets conformation.

Above: Façade of Saint Peter's Basilica, Carlo Maderno, 1612.

Below: Detail of the spiral column of the Baldachin.

SAINT PETER'S BASILICA

Saint Peter's Basilica > 4.3 is the biggest amongst the four papal churches in Rome and is the seat of Catholicism. The church was built in the place where Saint Peter was buried between 64 and 67 A.D. and became a symbol of strength for the Christian community. The basilica was commissioned by emperor Constantine in the fourth century, and it was consecrated by pope Silvester in 362. When the popes got back from Avignon at the end of the fourteenth century, Saint Peters' was in awful conditions. The basilica was then restored throughout the centuries and the various projects were given to well known architects such as Baldassarre Peruzzi, Michelangelo, Raphael, Antonio da Sangallo the Young and Carlo Maderno. The last architect to have worked on the church was Carlo Maderno, who followed Michelangelo's project to realise the façade. The latter had realised the project at the beginning of the sixteenth century following Donato Bramante's one. In fact, Bramante had been selected as the official architect for the basilica in 1506, but his ultimate design was much more reduced compared to what the pope had envisioned, and it was declared unfit to host a large number of visitors. Today Saint Peter's Basilica can accommodate 20,000 people.

It is designed as a three-aisled Latin cross with a dome at the crossing, directly above the high altar, which covers the shrine of St. Peter the Apostle. Saint Peter is the largest church in the world and is 115 metres long, preceded by a stair-

Above: Baldachin of Saint Peter, placed right under Michelangelo's dome.

Above, on the right: Personification of the *Caritas*, breastfeeding a baby, detail of the Sepulchre of Urbano VIII.

Facing, ont top left: Sepulchre of Urbano VIII, Gian Lorenzo Bernini, marble, wood and gilded bronze, Saint Peter's Basilica, 1628.

Facing, on top right: The face of the Madonna, detail from the *Pietà*.

Facing, below: Pietà, Michelangelo, white Carrara marble, Saint Peter's Basilica, 1499.

> **FUN-FACT**
>
> There's a well-known spot where you can see and optical illusion of Michelangelo's dome. If you head to **Via Piccolomini**, you'll see Saint Peter's dome well framed at the end of the road. What's unusual is that the more you get away from it the more the Dome gets bigger, creating a deceiving perspective. The cause lies in the street's conformation which generates this kind of illusion that plays with the building's dimensions.

case with three-level grounds, the white travertine marble façade is divided on two levels and has Corinthian pilasters and columns surmounted by an attic crowned by thirteen colossal statues.

The churchyard has a splendid stucco ceiling realised by Carlo Maderno, and two equestrian statues that welcome the visitor, one of Constantine by Bernini and the other one of Charlemagne by Agostino Cornacchini. In front of the portal, the atrium of the church hosts the important mosaic by Giotto called *Della Navicella*, depicting Jesus walking on water.

Even though the Basilica was rebuilt during the Renaissance, its interior is mostly Baroque and was decorated by Gian Lorenzo Bernini, who received the commission by Pope Urban VIII. The artist realized the famous **Baldachin of Saint Peter** (1624-1633), one of the best-known artworks inside the church. It took the artist nine years to finish the job which was finally located in its current position right under Michelangelo's dome. Its majestic structure doesn't alter the correct vision of the navy nor of the apse's decoration, but on the contrary, it creates a harmonic relation between the dome and the *Baldachin* itself. Bernini was inspired by a processional baldachin for the construction of the artwork which will be positioned right above Saint Peter's tomb. The peculiar Baroque form of the structure is composed by four twisted helical columns that are 20 metres high which support a cornice with four life-size angels on the corners. The bronze gilded baldachin combines sculpture and architecture and is decorated with motifs and symbols of the Barberini family such as bees and laurel.

Right in front of the baldachin stands the bronze statue of Saint Peter, realised in the thirteenth century by Arnolfo di Cambio and worshipped by the faithful, whose continuous rubbing has consumed its left foot.
Inside the church is also the **Pietà** carved by Michelangelo between 1497 and 1499, it represents the moment when Jesus, taken down from the cross, lies in his mother's arms. The splendid Carrara marble statue was the first and only piece ever signed by the artist and was realised using just one block of marble. A true sight for sore eyes, the Pietà combines the ideals of Renaissance beauty with an extreme sense of naturalism. The statue was vandalised in 1972 when a man attacked it with 15 hammer blows, and today is protected by a glass shrine.
Rising your gaze you'll see Saint Peter's dome, also known as **Michelangelo's Dome**. The dome was decorated by the artist, who was inspired by the one Brunelleschi had built in Florence; Its diameter is 42 metres, and it's supported by four massive pillars. An architectural masterpiece which was only completed after the artist's death in 1564. Right at the centre of the dome, divided by 16 windows, towers the fresco representing God surrounded by the evangelists in the mosaics on the pendentives.
Inside the church also lies the **Sepulchre of Alexandre VII**, carved by Gian Lorenzo Bernini, and dec-

Above: School of Athens, Raffaello Sanzio, fresco, Room of the Segnatura, 1511.

Facing, on the top: Detail from the *School of Athens*.

orated with polychrome marbles and statues, amongst them, the evocative representation of the Winged Death emerging from the tomb holding an hourglass in her hand. Another important tomb is the one of **Pope Innocent VIII**, on the left navy, realised by Antonio del Pollaiolo in 1498 and it's the only work from the old basilica that has been left in its original space. Another important sepulchre executed by Gian Lorenzo Bernini is the one dedicated to the countess Matilde di Canossa, who died in 115.

Right under the navy there's the *Grotte Vaticane*, an underground crypt, part of the ancient Constantinian basilica, where Christina, the Queen of Sweden was buried.

THE VATICAN MUSEUMS

The Vatican Museums > 4.4 occupy a large part of the Vatican land and host one of the biggest and most important art collections worldwide. The complex is composed by museums and the papal palazzo's rooms. Amongst them there's the Museum Pio Clementino, the **Museum Chiaramonti**, the **Egyptian Gregorian Museum** and the **Vatican Pinacoteca**, the **Sistine Chapel**, the Vatican Gallery of Maps and **Raphael's Rooms**. Seeing the whole collection in one visit is almost impossible so our advice would be to focus on its highlights. The last entrance to the museum is at 4 pm and to avoid long lines it would be advisable to book your visit online.

For a few years now the museums have been organising night openings from April to October which we truly recommend doing. Especially during the hot roman summers, seeing the museums at night will help you escape from the hot temperatures, and you'll have an unforgettable view of Raphael's Rooms.

> **FUN-FACT**
>
> The Vatican also hosts **the shortest railway in the world**! It measures no more than a thousand metres, and it links the Vatican to Saint Peter's station, on Italian soil. The trains are usually cargo, but occasionally are used by the pope himself.

RAPHAEL'S ROOMS

During his pontificate, Julius II redecorated the official papal apartments, originally painted by Pinturicchio for Pope Alexander VI in 1492. Initially, the ceiling decoration was given to Perugino, Sodoma, Bramantino and Lorenzo Lotto. It was only by the end of 1508 that Raphael joined the team of artists and begun working on the **Room of the Signatura**, the first one to be decorated. The Pope was very satisfied with Raphael's work to the point that he decided to entrust the artist with the decoration of all his rooms. In the Room of the Signatura, Raphael painted the personification of *Theology, Philosophy, Poetry,* and *law* in tondos on the ceiling, whereas he painted *Astrology, The Judgment of Salomon, The Original Sin* and *Apollo and Marsia* into small squares. The room was destined for the papal library and the pictorial cycle recalls the decorative pattern of mediaeval libraries, reflecting the reorganisation into different faculties.

In the Room of Signatura there's the famous frescoes, the *Disputation of the Holy Sacrament*, 1509-1510, and *The School of Athens*, 1509-1511. In the first one Raphael celebrates the church's mission, its predestination and revelation: he created a theatrical scene spanning both heaven and earth. At the very centre stands the consecrated host, representing the mystery of the reincarnation, illuminated by rays of light, surrounded by a crowd of ecclesiastics and saints. At the very centre there's the Holy Trinity, God, Jesus, and the dove of the Holy Spirit. Amongst the people in the lower part, we can spot some illustrious people of the time like Donato Bramante and Francesco Maria della Rovere, to whom Raphael probably owed his new job in service of the pope.

The *School of Athens* on the other hand has a monumental background; dominated by the imposing arcade, the fresco features an accurate perspective pro-

Facing, below: Plato and Aristotle, detail from the *School of Athens*.

jection, a defining characteristic of the Renaissance era, and he reproduced complex allegorical meaning linked to the history of Ancient Greek Philosophy, in relation to the modern Renaissance thinking. In fact, the *School of Athens* depicts a congregation of philosophers, mathematicians, and scientists from Ancient Greece; isolated from the top there's Plato and Aristotle. The two thinkers have been very important for Western thinking, and their different philosophies were incorporated into Christianity. Plato points up, as he believed in a higher and eternal reality, while holding his book the *Timaeus*. Aristotle on the other hand points down, as he believed that the only reality is the one we see and experience, while he holds his work, the *Ethics*. The features of the two philosophers resemble those of contemporary artists Michelangelo and Leonardo da Vinci, to whom Raphael wanted to pay homage. In the fresco we can spot a congregation of philosophers, mathematicians, and scientists including Pythagoras, Archimedes, and Heraclitus. Amongst the different philosophers, we can spot the currents of the Sophists, represented by Socrates and his followers, and the one of the Orphists. At the very centre, laying on the stairs, there's Diogenes, representative of the current of Cynicism. On the right side there's the group of Zoroaster, Tholomeus, Sodoma and Raphael himself.

Following, the Room of Heliodorus, was painted between 1511 and 1514, and served as an audience room. The main scene is represented by *The Expulsion of Heliodorus from the Temple*, which depicts a miraculous intervention in favour of the church against the enemy threats. The theatricality and dynamism of the scene is defined by the light, which defines the so-called "telescope perspective", highlighting the arches and domes and the character's gestures. The chromatic contrast between light and darkness also characterises the other paintings in the room, *The Mass at Bolsena, The Meeting of Pope Leo I and Attila,* and *The Deliverance of Saint Peter from Prison*. The latter celebrates the triumph of the first pope, who was imprisoned, and is divided into three scenes, each extremely symmetrical with a defined architecture.

All of the historical scenes depicted are of a high dramatic content: they go from an extremely harmonic universe that characterises the Room of the Signatura, to dramatic and more immediate ones, whose aim was to create a strong involvement with the spectator. Raphael managed to rapidly swift from one pictorial style to the other to keep the spectator in a state of awe.

THE SISTINE CHAPEL

The Sistine Chapel > 4.5 hosts the conclave and other important services that need such an elaborate frame which clearly expresses the concept of *Maiestas Papalis*. Construction work for the chapel began in 1477, commissioned by pope Sixtus IV della Rovere, and the first decoration of the chapel was executed by some of the great artists of the time like Perugino, Botticelli, Cosimo Rosselli and Domenico Ghirlandaio. Michelangelo on the other hand worked on the decoration of the chapel several years later, from 1508 to 1512, under the commission of Pope Julius II, Sixtus' nephew. When elected pontifex, Julius II, carried on the decorative and architectural programme of Rome, previously undertaken by his predecessor through the restoration and foundation of new buildings.

Michelangelo resumes the decorative cycle of the Sistine, painting the central vault with the nine episodes from *the Book of Genesis* (1508-12) and the *Last Judgment* (1536-1541) a large wall fresco situated behind the altar. At the centre of the vault, he painted the stories within smaller and bigger medallions; the smaller ones are framed by the figures of the *Ignudi* and the *Sibille*, ancient pagan gods, who seem to hold the frames of the scenes and support the vault itself. God's ancestors are painted in the lunettes, while the pendentives show the salvation of the Jewish population. The human figure is the absolute pro-

Above: Sybil, Michelangelo, detail from the ceiling of the Sistine Chapel, 1509.

Facing, on the top: Expulsion of Heliodorus from the Temple, Raphael, fresco, Room of Heliodorus, 1512.

Facing, below: Liberation of St. Peter, Raphael, fresco, Room of Heliodorus, 1514.

> ### FUN-FACT
> The Vatican is **the smallest country in the world** with an area of 0,44 kilometres and a population of 825 people. Oddly, there's no hospital in the Vatican soil, and consequently no one can actually be born a Vatican citizen. The state's citizenship can only be conferred by the Holy See. Furthermore, The Vatican is the only country that is entirely a UNESCO Heritage Site.

Above: Last Judgement, Michelangelo, fresco, Sistine Chapel, 1541.

Facing, on the top: Last Judgment, Michelangelo, Sistine Chapel, 1541.

Facing, below: Laocoonte and His Sons, Greek sculpture of the school of Rhodes, Museo Pio Clementino, Vatican Museums, first century A.D.

tagonist of the whole pictorial cycle, and the artist celebrates the beauty of the human body, from the figure of Adam to the images of the *Ignudi*.

The **Last Judgment** was commissioned to the artist by pope Clemens VII and was begun in 1536. The fresco is tragic and penitential; it immediately strikes for its overwhelming stylistic innovation. The composition is a whirlwind of figures, overlapping on a deep blue sky, traversed by large clouds, and all the groups of saints, prophets and patriarchs are circling the central figure of Christ. In the lunettes the angels hold the symbols of passion, while in the low-

er part are the scenes of salvation and damnation, with the resurrection of the bodies, the boat of Caronte and Hell's abyss opening underneath them.

The artist mostly focuses on the images depicting a painful illustration of humanity: the nature is only marginal, and the non-naturalistic colours are acid and conflicting. Unlike the vault decoration, *The Last Judgment* has no architectonical references, and there's no bearing element; the image is composed by a composition of figures.

MUSEO PIO CLEMENTINO

One of the Vatican Museums, the Museo Pio Clementino is composed by twelve rooms, including the Cortile Ottagono, and it hosts important ancient Greek and roman collections, amongst which the *Laocoon* group (I century B.C.) and the *Belvedere Apollo* (II century A.D.). Founded by pope Clements XIV in 1771, the museum hosts artwork from the Mattei and Fusconi collections, which were destined to host ancient masterpieces of the Vatican. Amongst the rooms there's the room of the animals, the statue gallery, and the busts room.

MUSEO CHIARAMONTI

Set up by Antonio Canova, the museum is composed by the Chiaramonti Gallery, the new *Braccio Nuovo* wing and the *Galleria Lapidaria*. Founded in 1807 the Gallery Chiaramonti is the oldest one and it exhibits urns, ancient sculptures, and sarcophagus. The Lapidary Gallery is only visitable by request, it occupies part of the long gallery designed by Bramante and it was born with the aim of creating a collection that included all of the Christian epigraphic evidence in contraposition to the pagan ones. In the collection there's more than four thousands inscriptions that come from different catacombs and necropolises.

THE EGYPTIAN GREGORIAN MUSEUM AND THE ETRUSCAN GREGORIAN MUSEUM

The Egyptian Gregorian Museum was founded in 1839 to host the papal Egyptian collection, it includes papyri, mummies and hieroglyphic inscriptions. The Gregorian Museum on the other hand boasts many of the archaeological finds that come from the Villa Adriana, and it articulates in nine rooms. The Etruscan Gregorian Museum on the other hand was built in 1836 with the purpose of hosting the Etruscan findings coming from the archaeological sites of recently found Etruscan cities. It is one of the first museums entirely dedicated to Etruscology.

Map Locations

- **Spagna** (M)
- **Barberini** (M)
- **Repubblica** (M)
- **Termini** (M)
- **Cavour** (M)
- **Vittorio E**

Points of Interest

- 5.1 Palazzo Massimo
- 5.2 Baths of Diocletian
- 5.3 Church of Santa Maria della Vittoria
- 5.4 Palazzo delle Esposizioni
- 5.5 Church of San Carlo alle Quattro Fontane
- 5.6 Church of Sant'Andrea al Quirinale
- 5.7 Piazza del Quirinale
- 5.8 Palazzo Colonna
- 5.9 Trajan Markets
- 5.10 Trajan Column
- 5.11 Vittoriano
- 5.12 Capitol Hill
- 5.13 Church of Santa Maria in Aracoeli

The Opera Theatre in Rome

Streets

- Via Pinciana
- Via Emilia
- Via del Tritone
- Via XX Settembre
- Via delle Quattro Fontane
- Via del Quirinale
- Via Nazionale
- Via Cavour
- Via Panisperna
- Via Giovanni Lanza
- Via Merulana
- Via Napoleone
- Via Mecenate
- Via del Plebiscito
- Fori Imperiali

Areas

- Parco Del Colle Oppio

Above: View of Capitol Square.

From Termini to Piazza Venezia

ROMAN NATIONAL MUSEUM OF PALAZZO MASSIMO

A few steps away from Termini's train station, **Palazzo Massimo** > 5.1 is the Roman National Museum. The building is inspired by the sixteenth century palazzos, but it was only constructed in 1883 as the headquarters of the Jesuit order, following the project of Camillo Pistrucci who had received the commission from the *Collegio dei Gesuiti*. The palazzo was then purchased by the Italian State in 1960 and converted into a museum. It now boasts a rich archaeological collection like the mesmerising bronze sculpture of the *Boxer at Rest*, and the white marble *Octavian Augustus* statue. The last floor hosts The Gallery of Paintings and Mosaics, entirely dedicated frescos, stuccoes, and mosaic decorations used in the sumptuous urban and suburban roman residences like Villa di Livia, Villa della Farnesina, Villa di Termini and Villa Pamphili.

BATHS OF DIOCLETIAN, BASILICA OF SANTA MARIA DEGLI ANGELI E DEI MARTIRI AND MUSEUM OF THE RESCUED ART

The cumulative ticket of Palazzo Massimo also includes the entrance to Palazzo Altemps, Crypta Balbi, the Baths of Diocletian and the Museum of Rescued Art. **The Baths of Diocletian** > 5.2 are right on the opposite side of the road. The ther-

FUN-FACT

Right next to Palazzo Massimo, on Via del Viminale, you'll see the now abandoned **Casa del Passeggero** (literally "House of the Passenger"). Extremely fascinating in its decay, the building was once a day hotel and it closed in the forties. It's been abandoned ever since but was used as a cinematographic set by Federico Fellini for his movie *Intervista*, and by Dino Risi for *Il segno di Venere*.

Above: Detail of the bronze statue *Boxer at Rest*, Roman National Museum of Palazzo Massimo, 329 B.C.

Below: Boxer at Rest, Roman National Museum of Palazzo Massimo.

mal complex was built between 298 and 306 A.D., and it originally extended for 13 hectares of surface and could contain 3000 people. The remains of the thermal complex include the *caldarium*, *tepidarium*, *frigidarium* and the ancient mosaics.

Part of the site is the beautiful *Chiostro di Michelangelo* (Michelangelo's cloister), in which is exhibited the huge inscription collection (almost 20.000), with an interesting section on ancient roman curses. Carved on iron sheets, the curses were found during the archaeological campaign in the area where today stands the Termini station. Particularly curious is the jinx against the charioteers, rolled up in a cinerary urn, it was addressed to two groups of jockeys that belong to two different racing factions.

Mid visit you'll be able to walk down the tombstones and roman steels in the cloister, and in its centre there's a fountain surrounded by massive equestrian statues. The Chiostro was built by Michelangelo where once stood the ancient *frigidarium* that belonged to the thermae. Originally the cloister was attached to the **Basilica of Santa Maria degli Angeli e dei Martiri**, on Piazza della Repubblica. Once visited the Basilica, a bit further ahead on the very same avenue, Via Emanuele Orlando, you'll run into the **Museum of Rescued Art**. The latter is set up inside the octagonal room that belonged to the Diocletian Baths, and inside it hosts all of the artworks confiscated and recovered by the Carabinieri Art Squad from looted archaeological excavations and illicit transportation.

THE FOUNTAIN OF THE MOSES AND THE CHURCH OF SANTA MARIA DELLA VITTORIA

Turning right on Via XX Settembre you'll see a huge marble sixteenth century fountain, **The Fountain of Moses** > 5.3, right in front of the **Church of Santa Maria della Vittoria** > 5.3. The latter was built following the project of Carlo Maderno (1608-1620), and is an evocative example of Baroque Roman art. The church is famous for housing Bernini's sculptural group, the *Ecstasy of Saint Teresa*, in the Cornaro Chapel. The theatricality of the scene is typically Baroque, and at its centre stands the figure of the Saint Teresa of Avila, swooning in a state of religious ecstasy, while a Cherub holds a spear to pierce her heart.

PALAZZO DELLE ESPOSIZIONI AND THE CHURCH OF SAN CARLO ALLE QUATTRO FONTANE

Palazzo delle Esposizioni > 5.4 is another building that stands out for its grandeur. Located on Via Nazionale, the museum

Facing, at the centre: Augustus as Pontifex Maximus, Roman National Museum of Palazzo Massimo, marble, first century B.C.

Facing, in the right: Detail of the statue of *Augustus as Pontifex Maximus*.

Above: Fountain of Moses, 1587.

FUN-FACT

Not far from Piazza della Repubblica you'll see a small green mid traffic triangle, filled with stalls, famous for selling *vintage* objects and books at a really convenient price. It's hard not to notice a huge obelisk, known as **Obelisco di Dogali**. The 17 metres high granite stele was built three thousand years ago in Egypt, under the reign of pharaoh Ramesses II. The obelisk was brought to Rome to be located inside the temple dedicated to the goddess Iside, that stood where today is the Collegio Romano. The Dogali obelisk was unearthed in 1883 and today is part of the monument dedicated to the battle of Dogali, after which the monument takes its name.

Above: Cloister of the Church of San Carlino alle Quattro Fontane, Francesco Borromini, 17th century.

On the top right: Ecstasy of Saint Teresa d'Avila, Gian Lorenzo Bernini, Church of Santa Maria della Vittoria, marble, 1647-1652.

FUN-FACT

The **Fountain of Dioscuri** is also known as the Fontana di Monte Cavallo because in the middle ages the square was called Piazza di Monte Cavallo due to the big equestrian sculptures that have been towering over the piazza since 1589. The roman obelisk is the imperial copy of an Egyptian one and was placed at the top of the fountain in 1786 as one can read in the curious epigraph at the base of the fountain, where the monument speaks as if it was in first person.

was built in 1883, following the neoclassical style of the great nineteenth century Expos. One of the first palazzos to be constructed specifically as a museum with the purpose of hosting the artworks that belonged to the great artistic currents. Today Palazzo delle Esposizioni doesn't have its own permanent collection and cyclically hosts great temporary exhibitions, so you'll have to check out their website and see what's on!

If you're looking for a short break after visiting the museum, we highly recommend trying out the food at the museum's café. The place is usually not very crowded and is beautifully set up.

You can then continue on Via Nazionale and take a left turn on Via delle Quattro Fontane where you'll see the beautiful **Church of San Carlo alle Quattro Fontane** > **5.5** right on the corner. Considered as an absolute baroque masterpiece, the church was built by Francesco Borromini. Its sinuous and wavy façade follows a rhythm that seems to reflect the light's vibrations and its *chiaroscuro* effects.

PIAZZA DEL QUIRINALE, PALAZZO DEL QUIRINALE AND THE SCUDERIE DEL QUIRINALE

Continuing on Via del Quirinale you'll pass another important church, **Sant'Andrea al Quirinale** > **5.6**, which was commissioned in 1658 by the Jesuits to the artist and architect Gian Lorenzo Bernini. The theatrical play of lights

and colours inside the small oval shaped church gifts the spectator with a singular emotional impact. Right after the church is **Piazza del Quirinale** > 5.7, a large square which stands right on top of the Quirinal Hill and has at its centre the monumental **Fountain of Dioscuri**, also known as Fontana di Monte Cavallo, whose statues were recovered from Constantine's Baths.

The piazza is also a perfect sunset spot, and it stands in between Palazzo del Quirinale and the Scuderie del Quirinale. The first one can only be visited through previous online booking and was erected as a private residence for the popes. Amongst the architects that worked on the palace there's Martino Longhi, Domenico Fontana, Carlo Maderno, and Gian Lorenzo Bernini. The palace has been the seat of the Italian monarchy from 1870 to 1947, when it became the seat of the Italian Republic. The Scuderie del Quirinale on the other hand were once the palazzo's stables and are today one of the biggest art institutions in the country.

For art history enthusiasts, not far from Piazza del Quirinale is the historical Accademia Nazionale di San Luca which you can visit for free. Aside for its prestigious permanent collection, the academy proposes a series of events and cultural initiatives.

On the top: Side view on Piazza del Quirinale, with the Fountain of Dioscuri.

Above: Cour d'honneur, Palazzo del Quirinale.

PALAZZO COLONNA, TRAJAN'S MARKETS AND TRAJAN'S COLUMN

Continuing towards Piazza Venezia, on Via Quattro Novembre, is the elegant **Palazzo Colonna** > 5.8. Not so easy to spot as it stands on the corner of the avenue, almost hidden, the palazzo will enchant you with its corridors, art gallery, private chambers, and gardens. In fact, despite being private, the palace weekly opens its doors to the public on Fridays and Saturdays. Amongst the artworks hosted by the gallery is the *Mangiafagioli* by artist Annibale Carracci.
One the very same avenue is also the **Trajan Markets** > 5.9 archaeological site. Particularly fascinating after sundown, when the monuments are lit up, the great roman complex was once linked to the forum and was believed to have functioned as a stock exchange. Right outside the Trajan Markets on your left you'll see the **Trajan Column** > 5.10. The mesmerising 40 metres tall monument (107-113 D.C.), is considered as one of the masterpieces of ancient art. The column has remained intact at its place ever since its inauguration in 113 A.D., and it celebrates the battles conducted in Dacia by the emperor Trajan, which are illustrated on the monument. The column also marked the exact height point where the Quirinal Hill linked the Capitol Hill.

VITTORIANO AND PALAZZO VENEZIA

Right at the centre of Piazza Venezia is the picturesque **Vittoriano** > 5.11, also known as Altare della Patria (the Altar of Fatherland), the National Monument dedicated to the late king Vittorio Emanuele II. Built between 1885 and 1935 to celebrate the Nation's splendour right after its unification, the altar is open to the public and at its top there's the Panoramic Terrace with a terrific view on the city. Inside the Vittoriano there's the Central Museum of the Risorgimento and the Imperial Forum Wing as well.

FUN-FACT

The *Equestrian Statue of Marcus Aurelius* (180 A.D.) is the only bronze statue from Imperial Rome to have survived to the present almost after two thousand years. It escaped the looting (bronze statues were usually melted for the material to be reused) because it was mistakenly believed the subject of the statue was Constantine, the first Christian emperor, and not that of a pagan ruler. Legend has it that amongst the horse's mane hides an owl, which will animate on the day of the Last Judgment to announce the end of times.

In 1921 was also added the Tomb of the Unknown Soldier, to commemorate the fallen of the First World War. Today in front of the Tomb there's a flame that never burns out and a laurel wreath is deposed on it during official ceremonies.
Right in front of the Vittoriano stands **Palazzo Venezia**, a very singular building, that belongs to the Roman Renaissance, erected between 1455 and 1467 for Cardinal Pietro Barbo, who later became pope Paolo II.
The Palazzo encompasses the Basilica of San Marco (336 A.D.), which is part of the side façade. Palazzo Venezia hosts a library and the famous Museum of Palazzo Venezia, established in 1921, whose collection spaces from decorative art to mediaeval and renaissance artworks.

CAPITOL HILL

The Capitol Hill > 5.12 stands between the Forum and the Campus Martius and is the smallest of the seven hills of Rome. In antiquity it was the seat of the temple of Jupiter Optimus Maximus, hence the name Capitolium which refers to Jupiter. Its central position made it the nerve centre for religious and political activities throughout the centuries. The majestic staircase that leads to the Capitol Hill is guarded by two Egyptian basalt statues representing two lions. On the staircase's sides, right before the square there's two colossal Dioscuri statues, roman copies of Greek original ones from the fifth century, found in the Circus Flaminio area, and located here in 1584.
Right at the centre of the square there's the ***Equestrian statue of Marcus Aurelius***, famous for being one of the rare bronze statues surviving from antiquity. The original one has been moved inside the Capitoline Museums and the one we see in the square is a replica.

Facing, on the top: Trajan's Market, beginning of the 2nd century A.D.

Facing, below: Decorative reliefs depicting the battles in Dacia, conducted by the emperor. Detail from the Trajan Column, 113 A.D.

Above: Capitol Hill, Capitol square, Church of Santa Maria in Aracoeli and Vittoriano.

Below: Equestrian Statue of Marcus Aurelius, bronze, II century A.D.

On the top: Buona ventura, Caravaggio, oil on canvas, Capitoline Museums, 1594.

Above: St. John the Baptist, Caravaggio, oil on canvas, Capitoline Museums, 1602.

The Capitoline Museums are composed by the Palazzo Nuovo and Palazzo dei Conservatori, both restored by Michelangelo. Palazzo Senatorio on the other hand is the emblem of the political palace of the city and was redesigned by Michelangelo under the pontificate of Pope Paulus III. It's adorned by colossal statues like the one of the *Dea Roma Capitolina* in the central niche and the other ones which are the personification of the river *Nile* and *Tiber*, both recovered from the Baths of Constantine.

The Musei Capitolini are the oldest public museums in the world. Funded in 1471 they're the main municipal museum structure in Rome. The museum boasts a huge archaeological and modern art collection. Inside you'll wander amongst wonderfully frescoed halls, like the *Sala degli Orazi e Curiazi*, where the huge wall fresco painted by Giuseppe Cesari reproduces the battle between the *Horatii* and *Curiatii*.

The ancient artworks are placed harmonically along the old fifteenth century halls, like the charming marble and bronze statue of *Artemide Efesina*. Amongst the best-known statues within the collection are *The Equestrian Statue of Marcus Aurelius*, the **Lupa Capitolina** and the Hellenistic group of the *Lion Biting the Horse*.

The modern art collection includes works by Caravaggio such as the **Buona Ventura** and the **St. John the Baptist**, and is divided into different sections: the Mediaeval one, the Renaissance once, the Fifteenth century Ferrarese period, the Fifteenth century Venetian period, the artistic currents between Emilia and

Above: Statue of *Marforio*, cloister of the Capitoline Museums, I century A.D.

Below: Bronze statue of the *Lupa Capitolina*, Capitoline Museums, 490-480 B.C.

Rome until the sixteenth century. To better orient yourselves we highly suggest the use of an audio guide or an introductive guide of the collection. At the end of the visit, you should check out the museums' terrace, which closes at 19.30 and has a breathtaking view over the city. Another less known panoramic spot is the gardens of Piazzale Caffarelli, right in front of the museums, on the Via delle Tre Pile, where you can stay how long you please and bring your own drink to enjoy the sunset.

CHURCH OF SANTA MARIA IN ARACOELI

The last attraction of the itinerary is the **Church of Santa Maria in Aracoeli** > 5.13, right next to the Capitol Hill. You can access the church by climbing a dizzying staircase of 122 steps at the end of which you'll be gifted with an amazing view, not for nothing the name Aracoeli literally means "altar of the sky". It seems like the church is literally suspended in the Roman sky. Inside the Basilica the huge hall is lit up with splendid chandeliers.

The church is an expression of mediaeval Rome, with a simple thirteenth century façade made of bricks, erected by Gregorio Magno on the Temple of Giunone Monete. It's believed that the modern structure was realised by Arnolfo di Cambio for the Franciscan order. In the last few centuries, the whole apparatus was modified, and the inside of the church is now divided into three aisles and contains the famous frescoes by Pinturicchio representing the *Funerals of Saint Bernardino*, and the *Tombstone of Giovanni Crivelli* by Donatello.

Map Labels

Viale delle Belle Arti
Via Ulisse Aldrovandi
Viale Giuseppe Mangili
Via Monte Zebio
Lungotevere Delle Navi
Villa Borghese
Lepanto M
Via Pompeo Magno
Viale del Muro Torto
Via di Ripetta
Via del Babuino
Via del Corso
Cola Di Rienzo
Via Virgilio
Via Tacito
Piazza Cavour
6.5 Villa Medici
6.4 Chiesa della Santissima Trinità dei Monti
6.2 Museum of the Ara Pacis
6.3 Piazza di Spagna
Palazzo della Cassazione
Via dei Condotti
Piazza Adriana
6.1 Castel Sant'Angelo
Tevere
Via del Tritone
Palazzo Altemps
Corso del Rinascimento
Tevere

From Castel Sant'Angelo to Piazza di Spagna

Above: View on *Sant'Angelo Bridge* and Castel Sant'Angelo.

CASTEL SANT'ANGELO

Built in 123 A.D. as a sepulchre wanted by emperor Hadrian for his family, **Castel Sant'Angelo** > **6.1**, like many other Roman constructions, served different purposes over the centuries, saving it from destruction and prevented it from being used as a quarry for materials. The Castle went from being a funerary monument to a fortress, from a prison to a renaissance residence, then again from dungeon to museum. In 403 A.D. the monument was included within the Aurelian walls and ever since it was converted into a *castellum*, owned by numerous different roman families, like the Crescenzi, the Pierleoni and the Orsini.

The stronghold became a papal fortress in the fourth century and in the thirteenth century pope Nicholas III (Giovanni Gaetano Orsini) constructed the famous passage called the **Passetto di Borgo**, which links the Vatican to the Castle and offered an escape route if the popes were endangered. Particularly is to remember the escape of pope Clemens VII who sought refuge in the fortress during the Sack of Rome in 1527. Today the structure hosts the Archive and the Vatican Treasures but was readapted as a court and a prison. Today the Museum is known as the **Museo Nazionale di Castel Sant'Angelo** and exhibits a rich collection of paintings, sculptures, military memorabilia, and historical weapons which were

FUN-FACT

For a time, capital executions took place right on the **Sant'Angelo Bridge**, and it was here that the young Beatrice Cenci was decapitated in 1599. It's said that her ghost wanders around the bridge on the night between the 10th and the 11th of September, headed to the castle, carrying her own head. The macabre legend is inspired by facts that happened in 1488, when the bridge became the place where heads and the bodies of the executed were exposed as a warning for the population, right where today we see Bernini's statues that metaphorically represent the via *crucis*.

Above: Side view on the mediaeval moat, fortress of Castel Sant'Angelo.

Below: Bronze statue of the archangel Michael, terrace of Castel Sant'Angelo.

used to defend the monument. The upper floors host the elegant Sala Paolina, the Paolina room, part of the chambers decorated during the Renaissance with the famous frescoes depicting the life of Alexander the Great; while on the terrace you'll get to see a beautiful view of Rome.

Carrying on the Lungotevere Tor di Nona, which then becomes the Lungotevere Marzio, you'll get to the **Museum of the Ara Pacis** > 6.2: a glass pavilion, extremely luminous and suggestive, built by Richard Meier, which stores the roman altar from which the museum takes its name. The pavilion was constructed by Richard Meier and it's right in front of Augustus mausoleum.

The *Ara Pacis* is one of the most significant pieces of evidence from the time of Augustus, mentioned in many ancient texts; it was inaugurated in 9 B.C. to celebrate the peace after the military operations in Gallia and Spain. The *Ara Pacis* was found underneath Palazzo Peretti Ottoboni Fiano and pieces of it were dug up in the course of the sixteenth century. The altar was entirely brought to light only between 1937 and 1938.

Above: Detail of *Bucranium*, decorative marble relief, Ara Pacis Augustae.

At the centre: Front view of the Sant'Angelo Bridge and Castel Sant'Angelo.

Below: Marble panel with the Tellus, *Ara Pacis Augustae*.

💬 FUN-FACT

The castle was once known as *Castrum Crescentii*, and on its terrace you'll notice the **sculpture of an angel drawing his sword**. Legend has it that in 590 A.D., during a plague pestilence that devastated the city of Rome, the archangel Michael paid pope Gregorio Magno a visit in his sleep, and with his flaming sword, announced him the end of the plague, which ended shortly afterwards. The pope commissioned a statue in honour of the angel which has been rebuilt various times in the course of history. The first version was made of wood and quickly deteriorated, whereas the second one is in marble and was destroyed during the goths siege in 1379. The bronze one that followed was then destroyed by a lightning in 1497 and replaced by another bronze angel that was used to forge cannonballs. The one we see today was built in 1753. Both the fortress and the bridge were named after this episode, hence the name Castel Sant Angelo.

Above: The *Ara Pacis Augustae* altar, 9 B.C.

Facing: The staircase of Trinità dei Monti, Francesco De Sanctis, Piazza di Spagna, 1723-1726.

The *Ara Pacis*, dedicated to the peace of Augustus, is composed by a rectangular marble enclosure finely decorated with reliefs, and elevated over a podium. It was built in the San Lorenzo area, which at the time of the consecration belonged to the countryside, along Via Flaminia (current Via del Corso), right on the "ideal line", the *Pomerium*, a mile close to the urban walls. The *Pomerium* was the exact point where the army, coming back from the war, would depose their weapons and the generals lost their military powers. Symbolically then, the *Ara Pacis* was built right where Augustus had declared the end of the war.

FUN-FACT

During the **archaeological excavations of the *Ara Pacis*** in 1568, nine marble blocks emerged from the ground. Initially were mistakenly attributed to an arch dedicated to Domitian and were purchased by the Grand duke of Tuscany. The fragments were sent to Florence, to France (now at the Louvre) and a part of it is now at the Vatican Museums. Curiously, some decorative fragments were used to adorn the façade of Villa Medici in Rome, where remain to this day.

PIAZZA DI SPAGNA

Once outside the museum, heading towards Via del Clementino, which becomes Via dei Condotti, you'll end up in **Piazza di Spagna** > 6.3. Alternatively, many other small alleys will guide you to one of the most beautiful squares in Rome. The piazza will open in front of you with its spectacular baroque staircase of Trinità dei Monti, commissioned by pope Innocent XIII to Francesco De Sanctis who built it between 1723 and 1726. The impressive architectural scenario finally fixed the height difference between the piazza and the Church of Santissima Trinità dei Monti, replacing the small trails on the Pincio hill.

The tripartite staircase is articulated in a succession of ramps, which in turn are divided in branches in a very sinuous course. The scenario looks even better in the springtime, when for about a month between April and May, beautiful, bloomed azalea plants are placed along the staircase.

At its base, at the centre of the piazza, stands the **Fontana della Barcaccia**, built as a memorial for the flooding of the Tiber in 1598. Its construction was com-

PIT STOP

Hard to miss, the beautiful **Grand Hotel Plaza**, on Via del Corso 126 is a luxury hotel built in 1837 for the Count Lozzano. Bought in 1902 by the Bartolini family, hotel owners from generations, the hotel was inaugurated in 1903. The enchanting palace is decorated with prestigious marbles, pilasters, and ceilings with painted vaults. Not everyone will be able to afford spending the night in this mesmerising hotel, but for those wishing to wander around the dark and melancholic rooms of the Plaza, we strongly recommend getting a drink or a coffee at the hotel's bar, the *bar Mascagni*. You won't regret it.

missioned by Urbano VIII in 1629 to the artist and sculptor Pietro Bernini, who realized the monument in collaboration with his son, Gian Lorenzo.

The fountain shows a perfectly symmetrical half stranded boat, placed slightly underneath the ground level as if it's sinking. In fact, back at the time, the Tiber often overflowed, and the water would drag boats and debris into the city centre.

Although, there's a technical reason why the marble boat is found at a lower level, and it concerns the water pressure. In fact, the aqueduct serving the fountain is the Aqua Virgo, the same one that "feeds" the Trevi Fountain. Because its conducts are found deep in the ground far away from the surface, the pressure of the water is weak, which is why both fountains are placed under the street level, position that allows them to have a powerful water jet, thanks to the higher pressure.

Going up the stairs you'll get to the **Chiesa della Santissima Trinità dei Monti** > 6.4, one of the five francophone catholic churches in Rome, founded by Charles VIII of France in 1493 and later restored in 1570 by Carlo Maderno and Giacomo della Porta. Not far is also Villa Medici, a sixteenth century villa that belonged to the Medici family, which houses the French Academy in Rome since 1803.

Above: Internal facade and private gardens of Villa Medici.

On the left: Gardens of Villa Medici seen from inside the Loggia, with the Fontana del Mercurio at its centre.

Facing: Fontana della Barcaccia, Pietro and Gian Lorenzo Bernini, Piazza di Spagna, 1598.

59

The Church of Sant'Agostino in Campo Marzio and the Madonna di Loreto by Caravaggio

7.2 Chiostro del Bramante and Church of Santa Maria della Pace

7.1 Piazza Navona

7.3 Church of Sant'Ivo alla Sapienza

7.7 Palazzo Braschi

Palazzo Massimo alle Colonne

7.6 Campo de' Fiori

7.4 Palazzo Farnese

7.5 Galleria Spada

From Piazza Navona to Campo de' Fiori

7

PIAZZA NAVONA

Piazza Navona > 7.1 is the most famous Baroque square in Rome and was built right on the site of the Stadium of Domitian (86 A.D.), hence its oval shape. The elegant palazzos overlook the square's perimeter, and the scenic piazza once hosted the *agones*, ancient roman games, and it was known as "*Circus Agonalis*" ("competition arena"). These games were also remembered and celebrated in the nineteenth century, when the square was flooded to recreate the famous *naumachia*, and the piazza hosted parades and processions.
In the sixteenth century, Pope Gregorio XIII, commissioned three fountains, but the modern asset which also includes the Church of Sant'Agnese, Palazzo Pamphilj and the surrounding buildings dates to 1600-1700.
The piazza has remained unchanged since then, bearing great appeal.
Amongst the palazzi we see in the square is **Palazzo Pamphilj**, built by the architect Girolamo Rainaldi, and frescoed by Pietro da Cortona, today it houses the Brazilian Embassy. Right next to it is the **Church of Sant'Agnese**, first constructed on the spot where the saint was martyrized. The church was restored by Rainaldi and Borromini under Pope Innocent X as the Palazzo's private chapel.

Above: Fontana del Moro, Giacomo della Porta, Piazza Navona, 1575.

On the following page: Fontana dei Quattro Fiumi, Gian Lorenzo Bernini, Piazza Navona, 1651.

AMBIENCE

It's possible to pay a visit to **Piazza Navona's suggestive subterranean levels**, seat of Domitian's stadiums ruins. Opened every day from 10.00 to 20.00. Informations are available at: 06 68 80 53 11 – 349 11 23 738
info@stadiodomiziano.com

Above: Façade of the Church of Sant'Agnese in Agone, Francesco Borromini, 1672.

Borromini's the author of the undulating façade that embraces the square, harshly criticised by his contemporaries due to its unusual concave curvature.

Piazza Navona hosts three monumental fountains; the biggest one is at the very centre, la **Fontana dei Quattro Fiumi**, and was designed in 1651 by Bernini for Pope Innocent X. Bernini's masterpiece plays on the balance and the contrast amongst the various elements of the complex like the marble rocks, and the perfect geometry of the obelisk standing right in front of the church, marking the centre of the square without being invasive towards the other units. The base of the fountain is composed of a basin supporting the personifications of the four river gods, the Nile, Ganges, Danube and Rio de la Plata. Wild animals drink from the water provided by the rivers. The obelisk originally comes from Circus Maximus and it's crowned by a dove, the emblem of the Pamphili family.

At the southern end of the piazza is the **Fontana del Moro**, sculpted by Giacomo della Porta and later retouched by Bernini. The first sculptor also realised the **Fontana del Nettuno** at the northern end that was left unfinished for a long time, and it's composed by four sculptural groups of sea deities that were added in 1878, amongst them the statue of the sea god fighting an octopus. Since the post-war period the square hosts artists, painters, and fortune tellers.

FUN-FACT

Bernini and Borromini, an endless rivalry. Stylistically very different, the two artists found themselves often working together or finishing each other's jobs. Bernini was a sculptor and an architect and at the time was more established than his colleague. Borromini on the other hand was mostly an architect, famous for his spatial solutions he created architectural masterpieces, but was less versatile than Bernini. Their conflictual relationship with time became a real rivalry. When in 1647 Borromini obtained the task of managing the complete renovation of Piazza Navona Bernini also presented an elaborate project for the centre fountain. The sculptor created the beautiful Fontana dei Quattro Fiumi that supposedly mocks Borromini. In fact, the face of the Nile statue is covered so as not to see the church of Sant'Agnese, which gives the impression of collapsing, due to the unusual façade built by Bernini's rival. Furthermore, the Rio della Plata has his arm extended almost as if he wanted to protect itself by the imminent collapse. This amusing story is probably just a legend as the construction dates don't correspond, but the tale has been passed down for centuries.

Above: Putto and Persian Sibyl, *Sibyls and Angels*, Raphael, detail.

On the top: Sibyls and Angels, Raphael, fresco, Church of Santa Maria della Pace, 1514.

Facing, on the top: Church of Sant'Ivo alla Sapienza, Francesco Borromini, 1660.

Facing, below: The dome of Sant'Ivo alla Sapienza, internal view.

PIT STOP

If you're longing for a good coffee or just a nice break, *Caffè del Chiostro* is the perfect place for you. It's a very fascinating place and inside the Cafè dedicated an exhibition space for emerging contemporary artists. If you're interested, You can submit your art sending your portfolio and curriculum to this email: social@chiostrodelbramante.it

CHIOSTRO DEL BRAMANTE AND CHURCH OF SANTA MARIA DELLA PACE

Wandering around the small streets behind Piazza Navona you'll run into Vicolo della Volpe and Vicolo della Pace where there's the small **Church of Santa Maria della Pace** > 7.2, commissioned by Pope Sixtus IV to an unknown artist, probably Baccio Pontelli or Meo del Caprino. In 1611 the façade of the church was modified and in 1656 pope Alexander VII commissioned its restoration to Pietro da Cortona, who realised the famous baroque façade on three concave wings, as if it was a theatre stage. The church expands along the piazza, taking the form of a trapezoidal asymmetric space. Inside is the famous Chapel Chigi, frescoed by Raphael for Agostino Chigi, the Pope's banker. The artist also painted the fresco of the *Sibyls and Angels*, located on the top right corner close to the entrance. Other famous artists that decorated the church are Baldassarre Peruzzi, Carlo Maratta, Pietro da Cortona, Orazio Gentileschi and Lavinia Fontana.

Annexed to the Church is the **Chiostro del Bramante** > 7.2 (1500-1504), designed by Bramante for Cardinal Oliviero Carafa, it originally belonged to the same complex of the church. The cloister forms one of the most important works of the Renaissance and today it hosts cultural events and numerous exhibitions of contemporary art.

CHURCH OF SANT'IVO ALLA SAPIENZA AND STATE ARCHIVE

The complex of Sant'Ivo alla Sapienza > 7.3 is composed of a church and a courtyard. The latter already existed before the church and has been the seat of the Sapienza University from its foundation in 1303 by pope Bonifacio VIII, until 1935 when it became the seat of the **State Archive**. The building was dedicated to Sant'Ivo, the patron of the lawyers and the courtyard was built by Giacomo della Porta. The Church on the other hand was conceived by Francesco Borromini in 1643 and the façade looks like a continuation of the courtyard arches. The church of Sant'Ivo alla Sapienza is unique as Borromini widely experimented fusing different geometrical shapes, incorporating a triangle with semi-circles, creating a harmonic effect between the sharp edges, the curves and the spheres expressing the passage from heavy and static elements to light and dynamic figures. This innovative experimentation of forms and spaces made Borromini the great pioneer of Baroque architecture.

The allegorical elements recall the bees, the emblem of the Barberini, the family of Pope Urban VIII who commissioned its construction. The shape of the church itself recalls the body of a bee. The lightness of the dome on the other hand recalls a spiral lantern, whose circularity is linked to God and to the triangular profile of the Trinity. Perfect synthesis of gothic and classical elements, the complex is of great charm and is opened to visitors only on Sunday mornings from 9.00 to 11.00.

AMBIENCE

Close by, the **Libreria Cascianelli** is placed right behind Piazza Navona in the small street of Vicolo della Pace. A true paradise for collectors and memorabilia seekers, the library has remained the same since the nineteenth century and it's very charming. You'll find all sorts of odd objects besides books and prints.

Above: Entrance porch, Palazzo Farnese, Antonio da Sangallo, 1541-1580.

Below: Il Trionfo di Bacco e Arianna, Annibale Carracci, fresco, Galleria Farnese, 1600.

Facing, on the left: Perspective Gallery, Francesco Borromini, Palazzo Spada, 1653.

Facing, on the right: Monument to Giordano Bruno, Campo de Fiori, Ettore Ferrari, 1889.

PALAZZO FARNESE

Palazzo Farnese > 7.4 stands out as one of the best examples of High Renaissance architecture in the city. The 16th century outstanding palazzo was commissioned by Alessandro Farnese, future Pope Paul III and its construction begun in 1517 under the guidance of the architect Antonio da Sangallo il Giovane. Works were then carried on by Michelangelo (1546-1549), Jacopo Barozzi da Vignola (1569-1573) and were finished by Giacomo della Porta in 1589.

Its construction was born in symbiosis with the opposite square because the whole complex was conceived as a single unit by the pope, who had the surrounding buildings torn down to build the square. The Villa was supposed to be a papal mansion and had to look accordingly. Inside the palazzo was decorated by Annibale and Agostino Carracci, Domenichino and Lanfranco. Outside in the front square there's two big twin fountains composed of granite basins, recovered from the Baths of Caracalla, and decorated by lilies, the symbol of the Farnese family. Today the palace is the seat of the embassy of France and visitors must book their guided tour on their website.

GALLERIA SPADA

Palazzo Capodiferro accommodates both a large art collection, **Galleria Spada > 7.5**, and the Italian Council of State. The beautiful palace was commissioned by Cardinal Girolamo Capodiferro in 1540, whose art col-

lection is exhibited today, along with the one of his grandnephew Cardinal Fabrizio Spada. The wide collection boasts work by Guido Reni, Orazio and Artemisia Gentileschi, Tiziano and Parmigianino. Inside the palace's cloister is the famous *Perspective Gallery* realised by Borromini in 1653. It's a *trompe l'oeil* arcaded courtyard, in which the diminishing row of columns create a visual illusion, and the gallery looks much bigger than its real dimensions (8 metres deep and the bottom statue is only 60 cm). Consequently, the garden looks wider.

CAMPO DE' FIORI

Campo de' Fiori > 7.6, not far from Galleria Spada and Palazzo Farnese, takes its name after the blooming gardens that occupied the land before the construction of the square. In the fifteenth century the piazza became an important meeting point, partly due to the construction of the Sixtus Bridge, which linked the two sides of the river, connecting Campo de' Fiori to Trastevere.
Campo de' Fiori was where processions, games and even capital executions took place. Right at the centre of the square stands the statue of **Giordano Bruno**, burned as a heretic in 1600. The piazza is also famous for hosting the market, since 1869 every morning from Monday to Saturday. Here you'll find fresh vegetables and fruit. Amongst the main attractions is **Palazzo Pio Righetti**, built in 1450 on the ruins of the ancient Theatre of Pompeo, for cardinal Francesco Condulmer. The façade is the result of the restorative interventions of the Orsini family that had eagles and lions sculpted on the windows tympanums.
The fountain at the centre of the square on the other hand is a nineteenth century replica of the original basin by Giacomo della Porta (1590).

FUN-FACT

Legend has it that by the end of the Sixteenth century, **Pope Sixtus V** liked to wander around the city incognito dressed up as a merchant, to find out what the people said about him. One day, while dining in a tavern in Piazza Navona, he overheard the host complaining about the pope's latest tax on wine which was high and harsh on the hosts and the punishment for those who failed to pay was jail.
The next day the pope ordered a guillotine to be placed in front of the tavern, and seeing it the host was excited as the execution would attract people to his pub. He was indeed less happy the moment he found out the pope came for his head. After his execution his friends had his face sculpted on the wall right above his old tavern in his memory. You can now spot the macabre sculpture at the civic number 34 of Piazza Navona.

Above: View of the cloister of Palazzo Braschi.

On the top right: Inside Palazzo Braschi, 1791-1804.

> ### 💬 FUN-FACT
>
> Right next to Campo de' Fiori there's a small, covered passage, known as **Passetto del Biscione** that links Via di Grotta Pinta to Piazza del Biscione. During the roman period this passage linked the *cavea* of the theatre of Pompeo with the outside area. In fact, it is to be noted how all the buildings in the small square chase a circular pattern that precisely follows the one of the ancient theatre of Pompeo, built in 55 B.C.

PALAZZO BRASCHI

In between Corso Vittorio Emanuele II and Campo de' Fiori is **Palazzo della Cancelleria**, historical headquarter of the Apostolic Chancellery since 1517 and of the courts of the Holy See. Built during the Roman Renaissance period, Palazzo della Cancelleria was commissioned by cardinal Raffaele Riario and its imposing and shining bright façade made of marble pilasters was inspired by Palazzo Ruccellai in Florence.

Little further on the same avenue is the **Giovanni Barracco Museum of Ancient Sculpture**, the ancient sculpture museum, that you can access for free. Its wide collection spaces from Egyptian, Assyrian, Cypriot, Phoenician, Etruscan, and Greco-Roman artworks. Right in front of it it's the beautiful **Palazzo Braschi** > 7.7, erected in 1791, commissioned by the prince Luigi Braschi-Onesti, sold by the family to the Reign of Italy in 1871 and until 1923 it housed the Ministry of the Interior. Palazzo Braschi has been housing the Museum of Rome since 1952 and it boasts more than a hundred thousand artworks that were saved from the city's demolitions.

The museum sheds light on the social and artistic history of Rome from the Middle Ages to the beginning of the 20th century and the second floor of the building hosts temporary exhibitions.

The charmingly decorated palazzo will immediately catch your attention, alongside the beautiful cloister that faces Piazza Navona. Amongst the other buildings worth mention-

ing on the busy street of Corso Vittorio Emanuele II is **Palazzo Massimo alle Colonne** and the church of **Sant'Andrea della Valle**.

The first one, is a renaissance masterpiece realised by the architect Baldassarre Peruzzi. The palace is private and its doors are closed to the public but you can still admire the porticoed façade, which is a tad curved, as the basement of the palazzo follows the perimeter of the ancient ruins of the Odeon di Domiziano, an ancient roman covered theatre. The optical illusion coming from this trick is typical from the Renaissance to make the palace look bigger than it actually is.

The **Basilica of Sant'Andrea della Valle** on the other hand is in Piazza dei Vidoni, erected between 1590 and 1650 by the architects Giacomo della Porta, Francesco Grimaldi and Carlo Maderno. Inside the church was decorated by important artists like Carlo Fontana, Gian Lorenzo Bernini, Lanfranco, Domenichino e Carlo Cignani.

The dome was conceived by the architect Carlo Maderno, and at the time it was only inferior to the one of Saint Peter. The architect Carlo Rainaldi oversaw the decoration of the façade which today only presents the statue of one angel on the left side. There's two legends surrounding the realisation of the statue; the first one sees Carlo Maderno and Rainaldi as protagonists. Apparently, the latter did not approve of Maderno's plan for the church which he felt was too high and not wide enough and asked the architect to change it numerous times. The architect wouldn't listen to him and Rainaldi out of spite only realised one angel on the left side of the building leaving the façade incomplete. Another story says that, once Rainaldi had finished the angel for the left side Pope Alexander VII criticised the sculpture, and as a response the artist never realised the second angel. Curiously, you'll find the statue of a very similar angel on the Sant'Angelo Bridge, also realised by Rainaldi.

On the top left: Palazzo Massimo alle Colonne, Baldassarre Peruzzi, 1532.

Above: The statue of the angel of sant'Andrea della Valle, Carlo Rainaldi, travertine, 1655-1665.

FUN-FACT

Every ancient palace has its secrets and the one of **Palazzo della Cancelleria** lies in its basement where in 1938 archaeologists found a roman sepulchre that belonged to Aulio Irzio, an official in Julius Caesar's army. The conditions of the discovery are very curious: the burial was found in the middle of a small underground lake of very clear water. As it turned out later, the lake was formed by an accumulation of stagnant water from the underground river Euripus, a tributary of the Tiber. The condition in which the tomb is presented is very suggestive and to this day it remains located in the same spot.

Bernini and the Galleria Borghese David

Spagna

8.4 Via Veneto

8.5 Church of Santa Maria Immacolata and Cripta dei Frati cappuccini

8.3 Piazza Barberini

8.2 Palazzo Barberini

Repubblica

8.1 Trevi Fountain

Cavour

From Piazza Barberini to Villa Borghese

Above: Trevi Fountain, Nicola Salvi, Giuseppe Pannini, 18th century.

TREVI FOUNTAIN

Nestled among the buildings of the historic center, the **Trevi Fountain** > 8.1 is the largest fountain in Rome, as well as one of the symbols of the city. Its hidden yet central position surprises those who come from the narrow streets of Via Poli and Via della Stamperia (which connect the square to Via del Tritone), Via delle Muratte and Via del Lavatore. The large complex is 26 meters high per 20 meters wide and leans against Palazzo Poli, altered to form the backdrop of the fountain. Trevi was built in the eighteenth century by Nicola Salvi commissioned by Pope Clement XII, right in the terminal point of *Acqua Virgo*, one of the ancient roman aqueducts, operating since 19 B.C. The name Trevi means "three roads" (tre vie) and was given to the complex because originally there were only three roads that led to it.

The fountain has a wide basin on which are a large marble cliff with plant decorations and at the very center of the scene is the statue of Oceanus driving a chariot pulled by two horses held back by two tritons. The idea of dynamism and movement is accentuated by the flow of the water and the scene actively involves the viewer, who is thus immersed in the composition. The spectacular nature of the complex did not leave indifferent film directors such as Federico Fellini who set here one of the most famous scenes of his movie *La dolce vita*, in which Anita Ekberg, in a sinuous evening

FUN-FACT

During the construction of the Trevi Fountain, the designer Nicola Salvi suffered harsh criticism from a barber, whose shop was right in front of the complex. Out of spite, Salvi had the sculpture of a large vase, now known as the **Ace of Cups**, sculpted on the side facing Via della Stamperia, thus preventing the barber from seeing the fountain from his shop.

CLEMENS XII PONT MAX
AQVAM VIRGINEM
COPIA ET SALVBRITATE COMMENDATAM
CVLTV MAGNIFICO ORNAVIT
ANNO DOMINI MDCCXXXV PONTIF VI

PERFECIT BENEDICTVS XIV PON MAX

dress, immerses herself in the sparkling waters of the fountain, inviting Marcello Mastroianni to join to her.
The cornice that crowns the façade of the building is adorned with decorations that allude to the legend of the spring and the history of the aqueduct. The Virgin Aqueduct and its springs are still active today and its pipes have been unrolling under the city for almost nineteen kilometers for more than two thousand years.

Facing: The Trevi Fountain with at its centre the important statuary group of Oceanus, travertine, marble, stucco, plaster, and various metals.

Above: Glimpse of the façade of Palazzo Barberini, 17th century.

On the following page: Judith Beheading Holofernes, Caravaggio, oil on canvas, Palazzo Barberini, 1599.

PALAZZO BARBERINI

From Via Stamperia, continuing on Via del Tritone you'll reach Piazza Barberini. Close to the latter is also **Palazzo Barberini > 8.2,** the former Barberini residence, now a museum. The palazzo stands out behind the imposing gate and the tall palm trees make the view fascinating, especially at sunset, when the warm sunlight reflects the white marble of the building.
The building houses the important National Gallery of Ancient Art and the Italian Institute of Numismatics and is the result of a Baroque extension of a pre-existing palace that belonged to the Sforza family, designed by Carlo Maderno, and continued by Bernini with the collaboration of Borromini between 1625 and 1633. The structure presents itself as "horseshoe-shaped", following the model of Villa Farnesina, with an atrium, an entrance loggia, and a backyard

AMBIENCE

One of the most famous legends surrounding the Fountain assures whoever throws a coin into the marble basin a future return to the Eternal City. Not everyone knows that every year kilos of coins are collected from the bottom of the fountain and that the daily amount is of three thousand euros for more than a million euros per year. The money is invested to restore the city's monuments.
Another curiosity concerns the **Fontanella degli Innamorati**, placed at the corner of the external side of the Fountain, in a rectangular basin with two small spouts. Legend has it that the couples who drink from it will remain in love forever. This custom was probably born in the last century, when military service was compulsory, and boys had to distance themselves from their loved one.

Facing, ont the top left: Portrait of Beatrice Cenci, Ginevra Cantofoli, Palazzo Barberini, 1650.

Facing, on the top right: La Fornarina, Raphael, Palazzo Barberini, 1520.

Facing, below: The spiral staircase, Francesco Borromini, Palazzo Barberini, 1633-1634.

Page 76: Triton Fountain, detail, Gian Lorenzo Bernini, 1625.

> **FUN-FACT**
>
> There's a story that involuntarily links two of the paintings exhibited at Palazzo Barberini: the one of **Beatrice Cenci** which links Caravaggio's *Judith and Holofernes* and the *Woman with a turban* by Ginevra Cantofoli.
> The painting by Cantofoli, probably active in Bologna in Elisabetta Sirani's workshop, is a presumed portrait of Beatrice Cenci, the protagonist of a late 16th century crime news.
> The young woman, accused of parricide together with her brothers, was beheaded on September 11, 1599, and, amongst the crowd of people who rushed to assist, was also Caravaggio who was so struck by the cruelty of the execution that he replicated it in his *Judith and Holofernes*.
> At the time, the intricate process was deeply felt and followed by the people, who made Beatrice a real heroine, to the point that stories and legends about her have come down to the present day.

garden. Of great impact is the decoration of the noble floor, where the famous fresco of the *Allegory of Divine Providence and Barberini Power* painted by Pietro da Cortona between 1632-1639, dominates the central ceiling.

Inside the palace is the Barberini collection, of enormous richness and variety, that hosts paintings such as the ***Judith and Holofernes*** and the *Saint John the Baptist* both painted by Caravaggio, *The Annunciation* by Filippo Lippi, the ***Woman with a turban*** by Ginevra Cantofoli, the *Self-portrait* of Artemisia Gentileschi and the famous statue of the *Veiled Woman* by Antonio Corradini. The palazzo's picture gallery is organized according to a chronological arrangement and includes the main pictorial schools from the thirteenth to the eighteenth century. Unlike Palazzo Corsini (also part of the National Gallery), which preserves a large part of the original collection, little remains of the family collection in Palazzo Barberini since the princes began to sell it as early as the eighteenth century due to hereditary disputes.

The sale intensified in 1934 after the Royal Decree was issued which allowed the princes to sell abroad. A small part of the original collection was acquired by the Italian State and is now signed with the letter "F" followed by numbers.

The building was purchased by the public administration from the Barberini heirs in 1949 with the aim of creating a museum, but the initial project slowed down because of various vicissitudes, and it was only in 2006 that the gallery was completely assigned to the Galleria d'Arte Antica. The rich-

ness and charm of the decorations inside the building, which can be accessed on the second floor via the **spiral staircase** designed by Francesco Borromini, are certainly worth a visit.

PIAZZA BARBERINI

At the beginning of Via del Tritone is **Piazza Barberini** > 8.3 which is located in an area that remained suburban until the nineteenth century, when it became an important part of one of the central districts of the capital. Today the square represents a junction between the Quirinale area, Villa Borghese and the Spanish Steps.

At the center of it is the **Triton Fountain**, by Gian Lorenzo Bernini, commissioned by Pope Urban VIII Barberini in 1625; entirely carved in travertine, it depicts four beautiful dolphins whose intertwined tails support a large open bivalve shell.

Some Roman fountains have been left untouched for millennia, others have been moved over the centuries finding new locations and some even got lost. The latter is the case for Bernini's Fontana delle Api, which is located at the corner between Via Vittorio Veneto and the square. The fountain was commissioned in 1644 by Pope Urban VIII and decorated with bees, the symbol of the papal family.

However, the Carrara marble artwork became a hindrance to traffic at the end of the 19th century and in was dismantled in 1865, moved from its original location and left in a

municipal deposit, where it disappeared under undefined circumstances; what we see today is a travertine copy made by Adolfo Apolloni which has replaced the original one in 1916.
Vittorio Veneto > 8.4 is the road that connects Piazza Barberini to Porta Pinciana and leads to the gardens of Villa Borghese. The avenue was initially dedicated to the Veneto region but was renamed after the First World War, commemorating the battle of Vittorio Veneto. Extremely popular for being the set of many films, Vittorio Veneto became famous especially thanks to Fellini's *La Dolce Vita*. The avenue hosts many fancy hotels and cafes such as Harry's Bar, the Hotel Majestic, Hotel Balestra, the Palazzo Coppedè, Hotel Excelsior, Palazzo Margherita (the American Embassy), Palazzo Piacentini (the Ministry of the Economic Development) and the Palazzo Marco Biagi (Ministry of Labor and Social Authority).
In the lower part of the street, next to the Fontana delle Api, is the **Church of Santa Maria Immacolata** > 8.5, founded by Cardinal Antonio Barberini, the younger brother of Pope Urban VIII.
The church was decorated by famous artists such as Pietro da Cortona, who worked on the first chapel on the right, Guido Reni, to whom is attributed the canvas of *Saint Michael Archangel*, Domenichino and Andrea Sacchi.
The Church is also known for its macabre crypts, where the bones of nearly 4,000 Capuchin friars are exhibited, collected between 1528 and 1870.

On the top left: Saint Michael Archangel, Guido Reni, Church of Santa Maria Immacolata, 1635.

On the top right: Fountain of the Bees, detail, copy of the original, 21 century.

FUN-FACT

Ironically it was right in Palazzo Barberini, residence of popes and princes, that the Socialist Party of Italian Workers was born in 1947 founded by Giuseppe Saragat, following the political split of the reformist wing of the Italian Socialist Party. The event is commemorated in a plaque affixed to the building.

AMBIENCE

If you're a contemporary art lover (or you just want to snoop around) you can pop by the **Gagosian Gallery**, located in Via Francesco Crispi, a side street of Via del Tritone. The only Italian branch of the Gagosian galleries, it exhibits works by established artists and, despite its exclusive appearance, anyone can enter and have a look.

Andrea Pozzo and the Glory of Saint Ignatius

Galleria Doria Pamphilj

9.4 Pantheon

9.3 Basilica di Santa Maria sopra Minerva

9.2 Teatro Argentina

9.1 Largo di Torre Argentina

Largo di Torre Argentina and Pantheon

Above: Pantheon and the Fountain of Piazza Rotonda.

We find ourselves in **Largo di Torre Argentina** > **9.1**, heart of the city, nestled between Piazza Venezia, the Jewish Ghetto and Corso Vittorio Emanuele II. Today the square is quite busy and is often seen as a crossing point to get to the nearby Pantheon or Piazza Navona; yet it was right in the centre of Largo Argentina that in 44 B.C. Caius Julius Caesar was assassinated, following the conspiracy against him organised by a group of senators led by Marcus Junius Brutus, Caesar's adopted son.

At the centre of the square is the archaeological area where the remains of four temples are lined up, three rectangular and one round, all facing east. They all date back to different eras and it's interesting to note the various and intricate phases of construction ranging from the third century to the second B.C. which can be distinguished by the different floors and ground height.

In addition to the three temples in the area there were buildings in *opus reticulatum*, public baths, the *Curia Pompeia*, the large portico of the *Hecatostilon* and the *Porticus Minucia*.

It is thanks to the pleas of the archaeologist Giuseppe Marchetti Longhi to the fascist regime that today the area is dedicated to the archaeological site. The complex was discovered during construction work in 1926 and today represents the most important nucleus of sacred buildings of the Republican age located in Campo Marzio. A feline colony carefully guards the remains.

FUN-FACT

The **Crypta Balbi**, also part of the Roman National Museum, is located on Via delle Botteghe Oscure and it hosts the headquarters of the Epigraphic Department. It stands on the complex of the ancient Teatro Balbo in Rome (13 B.C.) which was transformed into a workshop between the 5th and 9th centuries. Extremely interesting from an archaeological point of view, especially for the study of the various historical stratifications, the museum researches and documents the evolution of the underground space, its settlements, and its intended uses over the centuries.

Above: The archaeological site of Largo di Torre Argentina.

At the centre: Central nave of the Basilica of Santa Maria Sopra Minerva.

Facing, on the top: Annunciation, Filippino Lippi, Cappella Carafa, Basilica of Santa Maria sopra Minerva, fresco, 15 century.

Facing, below: The Elephant of Piazza della Minerva, Gian Lorenzo Bernini and Ercole Ferrata, marble, 1667.

Page 82: Glimpse of the Pantheon with marble decorative details of the Fountain in Piazza Rotonda.

The current square is the result of the 1920s expansion, when a pre-existing block of mediaeval origin was demolished, and took its name from the prelate and Renaissance theorist Johannes Burckardt (1445-1506) who had bought land in the area and was born in Argentoratum, the current Strasburg.

The Torre del Papito, on the other hand, which rises on the perimeter of the archaeological area, can be dated to the Middle Ages. In front of the sacred area is the **Teatro Argentina** > 9.2, one of the most important theatres of papal Rome, which in 1816 hosted the premiere of Gioacchino Rossini's *Barber of Seville*, and together with the Valle Theater it is the only one from that era that has been preserved.

As soon as you enter the theatre, you are immediately struck by the red velvet that covers the eighteenth-century large horseshoe-shaped hall, flanked by six tiers of boxes. The theatre, commissioned by Duke Giuseppe Sforza Cesarini, was built following the design of the Marquis Gerolamo Theodoli and was inaugurated in 1732. It became municipal property in 1869 and its current appearance is the result of the renovation made by Gioacchino Ersoch in 1887.

PANTHEON

Walking in the direction of Largo delle Stimmate from Largo Argentina and then continuing on Via dei Cestari, you'll end up in **Piazza della Minerva**.

The elegant square is dominated by the **Basilica of Santa Maria sopra Minerva** > 9.3, one of the very few examples of Gothic architecture in Rome, which rises in the area that in Roman times was dedicated to the temples of Minerva Calcidica, Isis, and Serapis. The origins of the church are traced back to the 8th century, but its completion dates to the 19th century. The square is also commonly called the "elephant square" because at its centre reigns a small Egyptian obelisk in red granite whose base is composed of a baby elephant designed by Gian Lorenzo Bernini and sculpted by Ercole Ferrata in 1667.

FUN-FACT

There's a funny anecdote concerning the **elephant of Piazza della Minerva**. When it was first constructed it suffered harsh criticism from the Dominicans, who questioned the stability of the obelisk. A stone cube was then added under the animal's belly as a support, which gave the sculpture the nickname of "Porcino della Minerva", or little pig; in vain Bernini tried to camouflage the cube by sculpting a saddle and a long saddle cloth. The offended artist, however, arranged the elephant with its bottom facing the Dominicans, who had the convent right in front of the square.

ALFCOSTERTIVM

Above: Architectural illustration of the Pantheon.

The sculpture is part of one of the nine Egyptian obelisks in Rome and dates to the 4th century B.C.; originally located in Heliopolis, it was imported by Domitian to decorate the Temple of Isis.

Continuing along Via della Minerva you'll get straight to Piazza della Rotonda, where the **Pantheon** > 9.4 imposingly stands out. One of the most famous Roman monuments for its grandeur, state of conservation and constructive wisdom, the Pantheon's original traces can be found two metres underneath the porch floor. It was built in 27 B.C. by Agrippa, restored by Domitian after the fire of 80 and rebuilt by Trajan later on in 118.

The works were finished by Antonino Pio, but Settimio Severo and Caracalla carried out further restorations, also remembered in the small inscription found under the main one.

The monument then remained abandoned for almost two centuries, until 608, when Bonifacio IV dedicated it to the Madonna and all the martyrs. During the following centuries the Pantheon was then stripped of its bronzes, in particular in 663 Constans II had the gilded bronze of the roof removed, then remade in lead by Gregory II, and in 1625 Urban VIII Barberini removed the bronze covering of the beams of the portico to build the 80 cannons of Castel Sant'Angelo and the four twisted columns of the *Baldachin of Saint Peter*. Subsequently several popes made changes to the temple, until the Pantheon became a shrine for the kings of Italy in 1870.

FUN-FACT

In the Pantheon there's a light effect that only occurs once a year, i.e., on **April 21 at noon**, when a beam of sunlight penetrates through the oculus of the dome, beautifully illuminating the entrance. April 21 is the so-called Christmas of Rome, the day in which the city's foundation is celebrated, and the light effect was specially designed by Agrippa. The intention was precisely to celebrate Rome's birthday at the stroke of 12, when the light would have fully illuminated the emperor as he entered through the bronze doors.

PIT STOP

Not far from the Pantheon, in Via Degli Uffici del Vicario is *Giolitti*, a historic ice cream parlour in Rome, open since 1900. Among the many delicious flavours, fruit lovers are strongly advised to get the *visciole* flavour, made with cherries typical of the area. A Roman peculiarity is that the ice cream makers always offer to garnish the ice cream with cream!

Facing: Detail of the beam of light crossing the interior of the hemispherical dome of the Pantheon.

On the left: One of the four grotesque masks of the Fountain in Piazza della Rotonda, detail, antique grey marble, travertine, Carrara marble, Proconnesian marble, red granite, bronze, Giacomo della Porta, 16th century.

AMBIENCE

One of the many urban legends tells that **raindrops never fall inside the Pantheon**, increasing the mystery surrounding the monument. This "miracle" has a grain of truth, in fact the oculus with a diameter of nine metres functions as an escape route for the hot air inside the building, thus creating an ascending current; therefore, if the rain is not too insistent, the hot current can repel the drops or disperse them. Reason why, it doesn't seem to rain inside the monument.

There's a macabre story concerning one of the **taverns facing the Pantheon**. At number 14 a large marble plaque reads «Pope Pius VII in the XXIII year of his reign, by means of a very providential demolition, reclaimed the area in front of the Pantheon of M. Agrippa, occupied by ignoble taverns, from the odious ugliness and ordered that the view was left free in an open place». In fact, among the taverns in the early nineteenth century one in particular was known for its famous sausages, which it was rumoured were prepared with the meat of some drunk customers, sometimes dragged by the innkeepers into the cellars. The innkeepers, as documented by the official documents, were tried and publicly beheaded. Although the authenticity of the story remains uncertain, at the time it caused such a stir that the pope, to restore the dignity of the place, had the inscription we see today hung there.

The circular structure of the Pantheon is 43 metres high and is made up of 16 monolithic columns in gray and pink granite, 8 on the front and the others arranged in depth to form three naves.

The bronze doors are not the original ones but date back to the sixteenth-century renovations, while on the door's sides are two niches which must have housed the statues of Augustus and Agrippa. Inside, the temple is divided into seven niches which house various burials and works of art including the *Annunciation* by Melozzo da Forlì and the *Madonna del Sasso* by Lorenzetto (1520). Among the burials are those of Vittorio Emanuele II, Raffaello Sanzio, Umberto I, Margherita di Savoia, the funeral monument of Baldassarre Peruzzi and the funeral epigraphs of Flaminio Vacca, Taddeo Zuccari and Perin del Vaga.

In the upfront square, to further embellish the view, is the great **Fountain of Piazza della Rotonda**, designed in 1575 by Giacomo della Porta, on behalf of Pope Gregory XIII. The structure of the fountain is polygonal with three steps and four masks on the sides.

- 10.2 Palazzo Mattei di Giove
- 10.1 Piazza delle Tartarughe
- 10.5 Palazzo delle Cinque Scole
- 10.3 Porticus Octaviae
- 10.4 Tempio Maggiore
- 10.6 Fabricio Bridge
- 10.7 Tiber Island

Jewish Ghetto

Above: Fountain of the Turtles, Giacomo della Porta, African marble and bronze, 1581-1588.

PIAZZA MATTEI

We find ourselves in Piazza Mattei, also known as **Piazza delle Tartarughe** > 10.1 with at its center the fascinating Fountain of the Turtles, commissioned to Giacomo della Porta between 1581 and 1588. Legend has it that the duke Mattei, from whom the nearby Palazzo takes its name, lost his family estate gambling, and his future father-in-law prevented him from marrying his daughter. As a response the duke commissioned the fountain, which was realized in just one night, to show off in front of his future wife.

The fountain represents the decorative focal point of the small square, with its rich decorations of shell-shaped basins in polychrome marble and travertine with the refined bronze attributes of ephebes riding dolphins; the turtles were added by Gian Lorenzo Bernini only in 1658.

Originally the fountain was served by the Virgin aqueduct, whose restoration in 1570 made it possible to build a series of fountains in the most populous districts of the city.

Placed in the historic center, Piazza Mattei is isolated from the city traffic and carves out a peaceful space, where you can sip a coffee in the square's bar Le Tartarughe or have a spritz in the suggestive Bartaruga bistro.

FUN-FACT

The **Fountain of the Turtles has a twin sister** in the United States. An exact copy of the fountain was commissioned in the early twentieth century by William and Ethel Crocker for the garden of their villa in San Francisco. The heirs of the owners decided later on in 1954 to donate the fountain to the city. The latter was thus placed inside Huntington Park, where it's still located today.

Next to Piazza Mattei, in Via dei Funari, is the beautiful **Palazzo Mattei di Giove** > 10.2, which today houses the Institute of the Ministry of Cultural Heritage and Activities, the Library of Modern and Contemporary History and the Center for American Studies.

The palace was built by Carlo Maderno between 1598 and 1611 for Asdrubale Mattei, the Duke of Jupiter. The interior has a great wealth of decorations and frescoes, including those by Pietro da Cortona, Giovanni Lanfranco and Domenichino.

The building is temporarily closed to visits, but you can always find an excuse to access the library and consult documents. In case your mission fails, you can console yourself with a good coffee at Enzo's bar, where Mrs. Eleonora will smile at you as soon as you cross the threshold.

JEWISH GHETTO

From Piazza Mattei you'll easily get to the Jewish Ghetto through Via Reginella. In the street there are numerous boutiques and art galleries including a curious shop called

On the top: One of the internal cloisters, Palazzo Mattei di Giove, 16th century.

Above: Solomon's encounter with the Queen of Sheba, Pietro da Cortona, fresco, Palazzo Mattei di Giove.

Facing: The archaeological site of the *Porticus Octaviae*, 27 B.C.

The Louvre Museum, a real chamber of wonders, where you'll find the most curious and disparate objects, perfect for an unusual and unique gift.
Looking at the ground on the very same street you'll notice some brass cobblestones engraved with names and dates. The latter are now present in many European cities and are known as **Stolperstein** (Stumbling block), made in memory of the victims of the Holocaust and placed right in front of the former houses of the deportees. On the Roman territory there's a total of 336 *Stolperstein,* while in Europe there are more than 50,000.
The Jewish Ghetto of Rome is one of the oldest in Italy, second only to the one of Venice and was born in 1555 at the behest of Pope Paul IV who relegated all Jewish people there with the obligation to wear an identification badge; they were also forbidden to trade or own real estate.
Today the ghetto is a small lively neighborhood that develops around Via di Portico d'Ottavia at the end of which is the archaeological site of the **Porticus Octaviae** > 10.3. The latter was a large rectangular square, bordered by a double row of columns and four monumental entrances, and its extension covered the entire space of today's ghetto. The enormous quadriportico, with almost 300 columns, was built by Augustus in 22 B.C. in honor of his sister Ottavia, on the ancient ruins of the Portico di Metella. In the Middle Ages, the fish market, called Foro Piscario, was held among the ruins of the portico, from which the Church of Sant'Angelo in Pescheria takes its name, located just behind the portico, and founded in the 8th century.

> **PIT STOP**
>
> In Piazza delle Cinque Scole there are two restaurants worth trying. The first *Sora Margherita* is far from the chaos of the neighborhood, and in the summer you can eat outside on the tables overlooking the beautiful square. I strongly suggest trying out the Cacio e Pepe pasta. Close by on Via di Santa Maria de' Calderari is the historic restaurant *Al Pompiere*, a tad more polished than the first one, it also offers a splendid view over the square. Both restaurants present typical dishes of Jewish cuisine on their menus, now integrated into the traditional Roman one, such as the artichoke *alla giudia* (Jewish-style artichokes) and the ricotta and *visciole* cake. The *Boccione* pastry shop is highly recommended although usually packed with people its famous ricotta cake is worth the line.

FUN-FACT

Legend has it that the **capitol engraved with four herm heads on the bridge** belonged to the four architects who were commissioned by Pope Sixtus V to restore the bridge. Shortly after the commission the architects started arguing on how to better restore it and the pope had them beheaded and a marble stele with four heads was erected, forcing the four to eternal coexistence.

The site it's accessible and it's possible to go down a small ramp and walk on the ancient street level.

Curiously, on one of the brick columns inside the site there is a marble slab with a Latin plaque that says "the heads of all fish that exceed the length of this plaque must be given to the Conservatori (high officials of the Capitol), up to and including the first fins", since the head of the fish was considered the most delicious part, excellent for soups. Those who transgressed this rule suffered severe punishments.

Another attraction of the neighborhood is the **Tempio Maggiore** > 10.4, the synagogue built in recent times, between 1901 and 1904 following the demolition of one of the most decadent areas of the ghetto.

Inside the imposing complex of the synagogue is the Jewish Museum of Rome which reconstructs the history of the ghetto from its origins. The art collection exhibited inside comes in part from **Palazzo delle Cinque Scole** > 10.5, which faces the piazza that was once divided by the ghetto wall into Piazza delle Scole and Piazza Giudea. Today, piazza delle Cinque Scole, whose name comes from the building that housed the five Jewish schools, is a small jewel; even if close to the chaos of the ghetto streets, it often remains empty and incredibly quieter than the rest of the neighborhood.

The imposing Cenci-Bolognetti private palace overlooks the square, and in the center is the large Weeping Fountain, commissioned by Pope Gregory XIII to Giacomo della Porta in the second half of the 16th century, so that "even the Jews could have refreshment".

The fountain was called "del Pianto" because it was originally located next to the Church of Santa Maria del Pianto, right on Piazza Giudea, the place where the crimes committed by the Jews were judged and where their pawns were auctioned.

TIBER ISLAND

From the Lungotevere de' Cenci you get to the **Fabricio bridge** > 10.6, which along with the Cestio bridge, connects to the Tiber Island. The Fabricio bridge, also known as the Ponte dei Quattro Capi because the parapet is decorated with four-faced herms of marble, is the oldest in the capital and maintains its original composition.
In 62 B.C. It was commissioned by Lucio Fabricio, as stated in the engraved inscriptions on the marble arches. In the following years, after the great floods, the bridge was restored in 22 B.C. and in 21 B.C.
Tiber Island > 10.7 was born from a thick layer of tuff and volcanic rocks in the middle of the river which favored the sedimentation of sand and river deposits. The easy ford that the island offered between the two banks of the river was one of the reasons for the foundation of Rome. A well-known strategic and sacred trading point since ancient times, the island housed the Temple of Aesculapius, inaugurated in 289 B.C. and built where today is the Church of San Bartolomeo. The island was called *Nave di Pietra* (Ship Stone), because it was decorated with white marble so that it resembled a ship, and some parts of its shape can still be seen today: the stern with a rudder and the figure and symbol of Aesculapius, the caduceus with an intertwined snake are still visible on the "prow" of the island, as well as some lion heads for anchoring boats. In the northern part, now occupied by the Hospital of Fatebenefratelli, there were two temples dedicated to *Fauno* and *Veiove*, Italic gods connected to the subsoil and the supersoil, and an altar dedicated to *Semo Sancus*, pagan god of faith, oaths, and honesty. Like all pagan temples, even those on the Tiber Island were destroyed in 998 A.D. and Otto III had the Church of San Bartolomeo built there. Even today the island maintains its sacredness, reinforced by the presence of the hospital, founded in 1584 and still operational today. In addition to the suggestive view, the church and the hospital, located on the island is also the famous Sora Lella restaurant; open since 1940, it's one of the classics in town.

Above: The Tiber Island and Fabricio bridge seen from the Lungotevere.

Facing, on the top: Fabricio bridge, 62 B.C.-23 B.C.

Facing, below: Four-headed hermae, marble, Fabricio bridge.

FUN-FACT

Before the nineteenth century, there were mainly **six bridges in Rome**, namely Ponte Sant'Angelo, Ponte Sisto, the two bridges of Tiber Island, Ponte Senatorio (that collapsed in 1598 and is now called Ponte Rotto) and Ponte Milvio. Since there were not many bridges, there was an alternative ferry service to transport people from one side of the river to the other. However, the traffic policy on the Tiber was strictly controlled by the state: the boats were a real public service and there were about ten official connections. Today Via della Barchetta recalls the traffic of the ancient service.

- 11.1 Teatro Marcello
- 11.2 Forum Boarium
- 11.3 Mouth of Truth
- 11.4 Church of Santa Maria in Cosmedin
- 11.5 Circus Maximus
- 11.6 Baths of Caracalla
- 11.7 Giardino degli Aranci
- 11.8 Basilica di Santa Sabina

Circo Massimo M

Ostiense
The Cestia Pyramid
Non-Catholic Cemetery
Basilica of Saint Paul Outside the Walls

From Teatro Marcello to Giardino degli Aranci

Above: The Archaeological area of Teatro Marcello, 55 B.C.

TEATRO MARCELLO

Teatro Marcello > 11.1 is the only ancient theater left in Rome and is easily accessible from the Jewish ghetto or from the Capitol, going down Via di Teatro Marcello. Not far from the Tiber, the monument is located in the southern area of Campo Marzio known as the *Circus Flaminius*, in the place that tradition had consecrated to stage performances (nearby was the Theater dedicated to Apollo). Its construction was commissioned by Caesar and was then dedicated by Augustus in 13 or 11 B.C. to the memory of his nephew and son-in-law Marcello.
In Rome, the theater was second only to the Theatre of Pompeo in chronology and capacity (15,000 spectators) and the *cavea* had a diameter of 130 meters. The original travertine façade had three architectural orders for 41 arches, with decorative marble masks, of which 12 of the Doric and Ionic order remain today.
The classical Roman theater was supported by masonry structures, unlike the Greek one which usually rested on a natural slope. The complex is a perfect example of historical continuity. In fact, it was abandoned in the 5th century and partly buried over the decades; it was used first as a quarry, then as a fortress and ultimately as a palace. In 1926 it was excavated and restored by Alberto Calza Bini. The theater today incorporates an old noble palace, Palazzo Savelli Corsini, commissioned by the Savellis in

FUN-FACT

Today **Palazzo Savelli Corsini** is divided into various apartments and has 431 square meters of cellars. Part of the building was put up for sale in 2012 for the modest sum of 32 million euros. Among the various apartments is Casa Litta-Palazzo Orsini, a wing consisting of four floors, formerly occupied by the Countess Valeria Rossi di Montelera Litta Modigliani, who in 1994 left it to the Order of the Knights of Malta.

Above: Temple of Portuno, Square of the Mouth of Truth, 80 B.C.

Below: Temple of Hercules Victor, Square of the Mouth of Truth, pavonazzetto marble, 120 B.C.

the 14th century to Baldassarre Peruzzi and then purchased by the Orsinis, dukes of Gravina, in the 18th century.

Going down towards Via Luigi Petroselli, you can come across numerous archaeological sites such as the Portico al Foro Olitorio, the Casa dei Crescenzi and the whole area of the *Forum Boarium* in Piazza della Bocca della Verità.

The **Forum Boarium** > 11.2 was a sacred area dedicated to the livestock market, but the environment went marshy and was then reclaimed with the construction of the nearby *Cloaca Maxima* between the 7th and 6th centuries. B.C Here you can also admire the **Temple of Ercole Vincitore** and the **Temple of Portuno**.

The first one has a circular monopteral structure in Pentelic marble that comes from the Greek models, and dates back to the 2nd century B.C. It was commissioned by the rich merchant Marco Ottavio Erennio, who dedicated it to Hercules, protector of the oil mills, trades and transhumance of flocks. This explains its location in the *Forum Boarium*.

The Temple of Portuno is instead rectangular and was built between 100 and 80 B.C. entirely in travertine with a tetrastyle portico of which only the eight frontal Ionic columns are free, the other six are inserted inside the cell. For centuries it was erroneously attributed to the temple of Fortuna Virile and it was only at the beginning of the twentieth century that it was identified as a temple dedicated to the god Portuno, the Roman god of ports.

CIRCUS MAXIMUS

Right in front of the Triton Fountain, on the opposite side of the street, is the **Mithraeum of Circus Maximus**. It is a vast and ancient complex discovered in 1931, belonging to the Circus Maximus and which in the 3rd century A.D. was adapted as a Mithraeum, a place of worship dedicated to the god Mithras, the Persian divinity of light.
Right next to the Mithraeum stands the Church of Santa Maria in Cosmedin, where the ancient **Mouth of Truth** > 11.3 is exhibited, a large marble mask associated with oracles and various deities such as Jupiter Ammone, the god of Ocean, and a faun.
The Mouth of Truth was born with the function of a manhole cover in ancient Rome, but over the centuries its fame grew exponentially thanks to the legends that surrounded it. In the Middle Ages some claimed that the mouth had the power to pronounce oracles, while another myth said that the devil was hidden behind it. Almost all the legends surrounding the *Bocca della Verità* (Mouth of Truth) show fear and reverence for the stone, capable of "deceiving with tricks" but also of "showing the truth", becoming such a popular attraction in Rome that it was reproduced in various prints. Today the best-known legend is the one according to which the liars who put their hand in it come out crippled.
In 1632 the large marble disc was placed under the beautiful medieval portico of the ancient church of **Santa Maria in Cosmedin** > 11.4, built in the 6th century above the altar of Hercules, of very ancient origin but rebuilt in the 2nd cen-

On the top: Circus Maximus, 6th century B.C.

Above: The ancient mask of the Mouth of Truth, Church of Maria in Cosmedin.

On the top: Archaeological complex of the Baths of Caracalla, 212-216 B.C.

Above: Triton Fountain, Piazza della Verità, travertine, 1715.

tury B.C. The church has an elegant Romanesque bell tower, and the interior is organized into three naves divided by pillars and 18 Roman columns.

Not far from the Basilica is **the Circus Maximus** > 11.5, the largest building for entertainment in antiquity, whose first construction dates back to the reign of *Tarquinius Priscus*.

According to the legend, the valley was already used as an area dedicated for competitions in honor of the god Conso, and it was during one of these that the episode of the *Rape of the Sabine Women* took place.

The imperial box was built by Augustus in 31 B.C. close to the Palatine Hill and in 10 B.C. the Flaminio Obelisk of Ramses II, now in Piazza del Popolo, was placed right in the middle of the *Circus Maximus*.

The latter has been rebuilt and expanded by several emperors throughout history, including Trajan and Caracalla and has an area of 85,000 m² by 600 m long, 140 m wide and could hold up to 300,000 spectators. Today the Circus Maximus has not lost its function and often hosts events and concerts. Not far from the Circus Maximus are the imposing ruins of the **Baths of Caracalla** > 11.6, one of the grandest monumental imperial architectural complexes of ancient Rome. Begun in 212 by Caracalla and inaugurated in 217, the Baths were then restored by Aurelian and remained in operation until 537, when the Goths cut the Antonian aqueduct which passed through the Appian Way, causing the formation of a malarial area.

The architectural plan was composed of a central body composed by the *frigidarium, calidarium, tepidarium*, the basilica, the Greek and Latin libraries and underneath which developed the vast underground rooms, so large that even horse-drawn carts could pass through them. Plundered for centuries and stripped of all precious materials, the baths were conceived by Caracalla to reflect imperial magnificence. They occupied eleven hectares of land and could accommodate up to 1600 people and the pools of water were decorated with mosaic floors, frescoes on the walls and sculptures.

The gigantic remains that still amaze us today can only partially give an idea of the Roman building capacity and the glory of the baths when they were first erected.

The complex of the Baths of Caracalla, like that of the Circus Maximus, hosts cultural events and hosts the summer season of the Opera Theatre in Rome: a great initiative to revive the archaeological area.

The concerts and shows inside the baths are in fact unique.

IL GIARDINO DEGLI ARANCI

You can either reach the **Giardino degli Aranci** > 11.7 following Via di Santa Sabina or walking along the fascinating path of Clivo di Rocca Savella. The Giardino is one of the most evocative and famous panoramic spots in Rome. Located on the Aventine Hill, the place, although often crowded, offers an enchanting atmosphere and a

Above: Baths of Caracalla, detail of the mosaic floor.

Below: Panoramic view seen from the Giardino degli Aranci.

FUN-FACT

Inside the Basilica of Santa Sabina in a dark corner you can see the **"devil's stone"** (*lapis diabli*). An ancient legend tells that in the 13th century the stone was hurled by Lucifer himself against San Domenico to lead him into temptation. However, the saint continued with his prayer unbothered. The black marble stone would therefore represent the tangible sign of the legendary event, even bearing the scratches left by the King of the Underworld, who is said to return from time to time to visit that sacred place where he was defeated.

beautiful panorama especially during sunset, with the western side of the hill overlooking the Tiber facing the Gianicolo. In Piazza Pietro d'Illiria is **Santa Sabina** > 11.8, one of the oldest early Christian basilicas in the city, surrounded by numerous legends and located in a place that is bewitching.

The 5th-century Basilica was built by Pietro d'Illiria, a Dalmatian priest, on a presumed primitive place of worship identified as the *Titulus Sabinae*, former home of the matron Sabina, and constitutes a model of the first Christian constructive concept that recalls the byzantine prototypes of Ravenna.

Of the very rich mosaics today remains the inscription in gold letters in memory of the builder of the church. The 24 Corinthian columns that divide the naves inside are from the Roman era and the cypress-wood portal has knockers with very ancient representations of the crucifixion carved on.

In the apse is a fresco by Taddeo Zuccari (1560) depicting Christ seated on the mountain surrounded by the sheeps drinking water, while in the atrium there are various materials recovered from the excavations of the church.

Through a small circular hole in the wall, you can see the beautiful thirteenth-century cloister, where at its center stands the oldest orange tree in the world. Legend has it that the tree dates back to 1220, when it was planted by San Domenico himself, and over the centuries the tree would sprout again every time it dried up.

The plant, with its miraculous properties, is the mother of all the other orange trees that were planted in the neighboring garden, making the area famous for the production of citrus fruits.

The Aventine Hill is also famous for being the historic seat of the Order of the Knights of Malta where flies a red flag, symbol of the Knights of the very ancient Order, established in 1048 with the aim of assisting pilgrims visiting the Holy Sepulchre. Over the centuries they became more and more influential and powerful and today the Knights remain active, sometimes touring the city with cars with SMOM (Sovereign Military Order of Malta) license plates.

The villa on the Aventine Hill was once a Benedictine convent that belonged to the order of the Templar Knights. The villa also includes the church of Santa Maria del Priorato, decorated with stuccos by Giovanni Battista Piranesi.

Facing: Annunciation, Taddeo Zuccari, basin of the apse of the Basilica of Santa Sabina, fresco, 1560.

At the centre: Villa del Priorato di Malta, Giovanni Battista Piranesi, 18th century.

Above: Saint Peter's dome seen from the famous key-hole on the Aventine Hill.

AMBIENCE

The clearing dedicated to the Order of the Knights is one of the most beautiful squares in Rome. The place, surrounded by high walls and gates and punctuated by neoclassical obelisks and stelae conceived by Piranesi, is one of the main attractions of Rome. Indeed, the Priory gate has a famous lock from which, once you look out, you can enjoy the **telescopic view of Saint Peter's dome**, theatrically framed by a pergola of trees.

- 12.8 Civic Museum of Zoology
- 12.9 National Etruscan Museum of Villa Giulia
- 12.10 National Gallery of Modern Art
- 12.7 Bioparco
- 12.5 Temple of Aesculapius
- Pietro Canonica Museum
- 12.6 Museum and Galleria Borghese
- 12.3 Villa Lubin
- 12.4 Fountain of Aesculapius

Villa Borghese

- 12.2 Church of Santa Maria del Popolo
- 12.1 Piazza del Popolo
- Hendrik Christian Andersen Museum

M Spagna

M Barberini

Repubblica

From Piazza del Popolo to Villa Borghese

Above: Pauline Bonaparte as Venus Victrix, Antonio Canova, white marble, Galleria Borghese, 1804-1808.

PIAZZA DEL POPOLO

Via del Corso connects Piazza Venezia to **Piazza del Popolo** > 12.1, the last great construction of papal Rome. The square is closed by the homonymous gate, which overlooks Viale Luisa di Savoia.
Framed by the ramps of the Pincio promenade, Piazza del Popolo was designed as a large space, able to amaze the pilgrims when entering the city, as it combines urban and architectural aspects with natural ones. The wonderful square we see today is the result of three and a half centuries of alterations, from the reconstruction of the church of Santa Maria del Popolo to the current neoclassical conformation of the late 19th century, by Giuseppe Valadier.
In 1589 the oldest and tallest (36 meters including the base) obelisk in Rome, previously located in the *Circus Maximus* was placed in the middle of the square.
The Flaminian Obelisk was built in Egypt in 1300 B.C. and was brought to Rome in 10 B.C. at the behest of Octavian Augustus, who decided to keep the original dedication to the god Ra (god of the Sun), which corresponded to the Roman god Apollo, the divinity that represented the emperor.
It's impossible not to miss the two imposing travertine fountains that stand at the center square, right under the obelisk. The fountains are composed by basins in the

FUN-FACT

The name **Piazza del Popolo** has an uncertain origin, perhaps linked to the deposition of Nero's ashes under the Church of Santa Maria del Popolo, since then considered haunted by ghosts. A more credible version attributes the name to the long row of poplars (*populi* in Latin) on the avenue along the Mausoleum of Augustus.

Above: Conversion on the way to Damascus, Caravaggio, Cerasi Chapel, Church of Santa Maria del Popolo, 1600-1601.

On the top: The monumental fountain with at its centre the statue of the Dea Roma, on the slopes of the Pincio, Piazza del Popolo, Giuseppe Valadier, 1823.

shape of large shells, surmounted by sculptural groups and were created by Giovanni Ceccarini who followed a pre-existing project by Valadier, and represent Neptune on one side, in between two tritons, and on the other the Goddess Rome amongst the rivers Tiber and Aniene.

Right next to Porta del Popolo stands the beautiful **Church of Santa Maria del Popolo** > 12.2, whose origins date back to 1099 when the first nucleus was built, right on the mausoleum of the Domizi where Nero was buried.

The church was then enlarged and passed on to various confraternities until 1472 when it reached the Lombard Congregation, which modified the basilica according to the Lombard style.

Despite the uncertainties over the identity of the church's architect, it underwent various interventions during the sixteenth century by Bramante, Carlo Maderno, Raphael and Bernini. The façade is in travertine marble and inside there are numerous famous chapels and works, including the Nativity by Pinturicchio (1500-1501).

Inside are also the Chigi chapel and the Cerasi chapel; the first one was designed by Raphael as a mausoleum for the Chigi family and was begun in 1513 and completed in 1652. Full of allegorical meanings, the chapel is a harmonious room with a central plan with decorations by Francesco Salviati and Sebastiano del Piombo.

The Church is mostly known for housing the Cerasi Chapel that hosts the famous paintings by Caravaggio the **Conversion of Paul the Apostle** *(1600-1601)* and the *Crucifixion of Saint Peter* (1601), along Annibale Carracci's *Assumption* (1604).

VILLA BORGHESE

In Piazzale Flaminio is one one of the monumental entrances to the **Villa Borghese Park**, made with neoclassical propylaea (1827), overlooking the façade of Porta del Popolo and bordered by the Aurelian walls. What is now a public park was born as the park of the villa of Cardinal Scipione Borghese Caffarelli, nephew of Paul V, who had a suburban villa built mainly for his art collection, in a family-owned area. The task was entrusted to Flaminio Ponzio in 1608 but the expansion project was overseen by Luigi Canina in 1822, while part of the villa was sold to the Italian state which ceded it to the municipality of Rome in 1903.
Continuing along George Washington Avenue you'll pass by **Villa Lubin** > 12.3, an example of neo-baroque and liberty architecture, built by Pompeo Passerini in 1906. Today the Villa hosts the headquarters of the CNEL. Passing the Villa you'll see the beautiful **Fountain of Aesculapius** > 12.4, and close by is also the **Temple of Aesculapius** > 12.5 (1785), which stands on a small island in the center of the park's artificial lake. The Temple houses the ancient statue of the god, which was restored in 1785.
The lake is a true point of peace within the park and there are many tourists who rent boats to go for a ride; the place is even more romantic at night, when the illuminated temple reflects on the dark water of the lake.

On the top: Temple of Aesculapius, Gardens of Villa Borghese, 18th century.

Above: Fountain of Moses, Gardens of Villa Borghese.

103

Facing: Hall of the Emperors, set up by Antonio Asprucci, Galleria Borghese.

On the left: Boy with Fruit Basket, Caravaggio, oil on canvas, 1593.

Below: Rape of Proserpine, Gian Lorenzo Bernini, marble, Galleria Borghese, 1621-1622.

On the following page, on the top: Sarcophagus of the Spouses, detail, terracotta, VI sec B.C., National Etruscan Museum of Villa Giulia.

On the following page, below: The spectacular nymphaeum of Villa Giulia designed by Bartolomeo Ammannati.

As you walk, let yourself be amazed by the numerous attractions in the park that often appear in the middle of the path when one least expects it, as in the case of the Temple of Diana by Mario Asprucci (1789), the Orangery, used as a warehouse for citrus fruits, or of the neoclassical complex of the Portico dei Leoni.

The Uccelliera (The Aviary) by Girolamo Rainaldi and the Building of the Meridiana 1688 are also worth a visit. Among the majestic fountains present in the park we should mention the Mostra dell'Acqua Felice di Giovanni Fontana (1610), the Fontana delle Maschere di Giacomo della Porta (1575), the Fontana dei Cavalli Marini di Cristoforo Unterperger (1790).

In Viale del Museo Borghese is the **Casino Borghese**, home to the **Galleria Borghese Museum > 12.6**. The Borghese Museum houses the ancient art collection of Cardinal Scipione which was expanded from the beginning of the seventeenth century to the end of the eighteenth century, when the exceptional complex of works was arranged in the halls of the palace.

In 1807 the collection was given away by Prince Camillo to France and never returned to his homeland, constituting today the main nucleus of the classical art section of the Louvre. The current collection consists of the surviving sculptures and artworks that were found in the park or that were housed in other family properties.

Among the masterpieces of **Galleria Borghese** there are wonderful works such as the *Venere Vincitrice* by Antonio Canova (1805) in the Sala Del Vaso, the *David*, the *Apollo and Daphne* and the **Rape of Proserpine**, masterpieces by Gian Lorenzo Bernini and the **Boy with Fruit Basket** (1593) and the *Madonna Palafrenieri* (1605) by Caravaggio. The *Danae* by Correggio (1530), the *Deposition of Christ* by Raphael (1507) in the Sala di Didone, the *Portrait of a Man* by Antonello da Messina (1474) and the *Head of a Young Man* by Lavinia Fontana (1606) are admirable.

Inside the park is also the **Bioparco** > 12.7, inaugurated in 1911 as a zoo designed by the architect Carl Hagenbeck. The Bioparco is today a zoological garden, whose current foundation took place in 2004, where the animals wander freely and are not locked up in cages. Visitors can admire endangered species and will have a chance to educate themselves on the protection of biodiversity and scientific research.

Right next to the Bioparco is the **Civic Museum of Zoology** > 12.8, with a heritage of about 5 million preserved specimens, ranging from mollusc shells of a few millimeters to the skeleton of a 16-meter whale. An educational experience especially suitable for families with children.

NATIONAL ETRUSCAN MUSEUM OF VILLA GIULIA

The beautiful National Etruscan Museum of Villa Giulia > 12.9 stands on Viale delle Belle Arti and collects the testimonies of

ancient Iron Age and Roman civilizations in Lazio, focusing particularly in the area between the Tiber and Tuscany. Villa Giulia hosts one of the most important Etruscan collections in Italy, including masterpieces from various necropolises such as that of Cerveteri and of Olmo Bello di Bisenzio but also from ancient cities such as Veio, Pyrgi and Vulci.

The itinerary proposed by the museum is very didactic and useful to understand the various historical periods of the Etruscan civilization and the masterpieces include the funeral equipment of the *Tomb of the Warrior* (second half of the 6th century B.C.), the *Sarcophagus of the Spouses* (530 B.C.), the *Chigi Vase* (640 B.C.) and the famous *Pyrgi Tablets*, golden laminae engraved both in Etruscan and Phoenician, a fundamental discovery for the study of the Etruscan language.

The splendid villa was commissioned by Pope Julius III in the 16th century as his suburban villa and remained the property of the Roman Curia until 1870, when it passed to the state and was turned into the National Etruscan Museum.

The complex develops around the fascinating nymphaeum and the architect focuses on the harmony created by the architectural and natural elements of the garden. The construction project was entrusted to Jacopo Barozzi from Vignola in 1551, but architects such as Bartolomeo Ammannati, Giorgio Vasari and Michelangelo Buonarroti also worked on it. Villa Giulia is a striking example of Mannerist architecture and one of the most beautiful museums in the City.

NATIONAL GALLERY OF MODERN ART

Not far from the Villa Giulia Museum is the **National Gallery of Modern Art** > 12.10, which houses an important collection of sculptures, paintings and graphics by mainly Italian artists from the 19th century to the present day. The nearly 20,000 works are precious evidence of Italian historical artistic currents and avant-gardes from Neoclassicism to Surrealism. The collection also focuses on Italian contemporary artistic avant-gardes between the 1920s and 40s, and the nucleus of artworks that belong to the Scuola Romana movement is particularly emphasized.

The Gallery was founded in 1883, when the new Italian State led the institutional foundations and promoted the development of a national art, getting worldwide prestige thanks to the important acquisitions of Italian artworks by Alberto Burri, Ettore Colla, Lucio Fontana, Piero Manzoni and the international acquisitions of artists such as Piet Mondrian, Henry Moore, Jackson Pollock etc.

The Museum regularly hosts exhibitions and is known for its commitment to promoting themes and conferences that use art to raise awareness of contemporary issues. If you are a lover of contemporary art, we recommend that you spend a few hours wandering around the large bright rooms of the gallery.

On the top: Dreams, Vittorio Corcos, oil on canvas, National Gallery of Modern Art, 1896.

Above: Portrait of Jane Morris, Dante Gabriel Rossetti, pastel on cardboard, National Gallery of Modern Art, 1868-1874.

History of the Coppedè district

13.4 MACRO - Museum of Contemporary Art in Rome

Villa Massimo

Villa Torlonia

Bologna Ⓜ

Policlinico Ⓜ

Castro Pretorio Ⓜ

Sapienza Università di Roma

Street art in San Lorenzo

13.1 Basilica of San Lorenzo fuori le mura

13.2 Monumental Verano Cemetery

The Baker's Tomb

13.3 Fondazione Pastificio Cerere

San Lorenzo

Above: One of the porticoes inside the Monumental Verano Cemetery, 18th century.

San Lorenzo is a relatively young district that was born in the second half of the nineteenth century, after the unification of the Kingdom of Italy and the subsequent urban development; it was a so-called "dormitory district" with no real infrastructure and housed workers from all over Italy. Before then San Lorenzo was characterized by a substantially agricultural landscape.

During the twenties San Lorenzo was the place where various popular anti-fascist revolts took place, thanks to the presence of two important factories, the Cerere pasta factory and a brewery.

In 1922 the district resisted the march on Rome and there were hard fights between the fascists and the Arditi del Popolo, who together with the population blocked the entrance to *the squadristi*; for this reason, it was called the "red quarter". San Lorenzo was hit hard by the bombings of the Second World War and its reconstruction was rather slow and complex. In the 1930s, the University City was built in the north side of the district, the new headquarters of the La Sapienza University, which today boasts the highest number of students in Europe.

The name of the area comes from the **Basilica of San Lorenzo Fuori le Mura** > 13.1, part of the "tour of the seven churches", a pilgrimage itinerary practiced since the Middle Ages. The basilica is composed of two primitive churches, the minor basilica and the major one. It was built at the behest of Constantine in 330,

♥ AMBIENCE

San Lorenzo was destroyed by the Anglo-American bombings and has recently risen turning into a neighborhood full of life, art, and students. In San Lorenzo you'll run into small blocks of flats, shops and artisan shops where craftsmen work manifold materials such as wood, marble, iron, steel, glass and ceramics. In the neighborhood, is the ancient Verano cemetery, which inspired Ugo Foscolo in his *Dei Sepolcri*.

Above: Basilica of San Lorenzo fuori le mura, detail of the Cosmatesque floor.

On the right: Episcopal throne, Basilica of San Lorenzo fuori le mura, 330.

in honor of the martyr Lorenzo. The minor basilica was built by Pope Pelagius II in the sixth century, right above the martyr's tomb. The two buildings were then joined by Pope Honorius III in 1216, who had the apse demolished. Today the church is formed by a presbytery which is part of the Basilica of Pelagius, by a central nave and two lateral ones. The church was rebuilt following the heavy Anglo-American bombings of 1943 which damaged the interior and caused the central nave to collapse.

San Lorenzo Fuori le Mura was already protected militarily from the barbarian invasions of the 12th century by Pope Clement III, who had a fortified wall built with towers and merlons still visible today, creating a real citadel, called "Laurenziopoli", including the church, the cloister, the bell tower and the service buildings.

Although being of the few churches in the capital to be protected militarily, it was destroyed during the last World War, because the walls that defended it for almost a millennium were not prepared for the devastating modern war.

The district develops around the most important cemetery, as well as the first municipal cemetery of Rome, the **Monumental Verano Cemetery > 13.2**, which owes its name to the ancient Campo dei Verani (*gens senatoria* of the Republic) and was founded during the Napoleonic rule (1809-14), when the edict of Saint-Cloud imposed the displacement of all cemeteries outside the city walls.

The area was also a burial place in ancient Rome, and several catacombs were found nearby, including the Catacombs of Santa Ciriaca. All the citizens of Rome who died between 1860 and 1980 were buried inside the cemetery, excluding popes and cardinals. There are also many burials of famous people such as Errico Malatesta, Goffredo Mameli, Trilussa, Giuseppe Ungaretti, Gianni Rodari, Grazia Deledda, Giacomo Balla, Sibilla Aleramo, Alberto Moravia, Eduardo De Filippo, Vittorio Gassman, Nino Manfredi, Vittorio De Sica and Alberto Deaf.

A luxuriant and uncultivated nature has thrived in the extended cemetery, which takes possession of the ancient burials, giving a further charm to the austere atmosphere that reigns over the place. Another interesting attraction in

San Lorenzo is the **Fondazione Pastificio Cerere** > **13.3**, the oldest former factory in the neighborhood. Born in 1905, it supplied pasta and bread to the city until it shut down in 1960 after 55 years of activity. In the seventies, however, some rooms of the building were rented to the young artists Nunzio, Bruno Ceccobelli, Gianni Dessì, Giuseppe Gallo, Pizzi Cannella and Marco Tirelli, known today as part of the Nuova Scuola Romana group, an avant-garde group who became well known thanks to the exhibition "Ateliers" curated by Achille Bonito Oliva right in the former pasta factory in 1984.

Since 2004 the former factory has been converted into a center for contemporary art and regularly hosts exhibitions. Talking about contemporary art, about thirty minutes on foot from the Foundation is **MACRO, the Museum of Contemporary Art in Rome** > **13.4**, built by the French architect Odile Decq on the site where once was the former factories of the Peroni brewery.

The museum has a permanent collection that is exhibited cyclically, but the main focus is on temporary exhibitions.

On the top left: Funeral monument of Goffredo Mameli, Monumental Verano Cemetery, 1891.

On the top right: Sculpture of an angel inside the Monumental Verano Cemetery.

Above: Interior of Monumental Verano Cemetery.

N
Via Gallia
Via Cristoforo Colombo
Via Cilicia
Via Casilina
Ⓜ Ponte Lungo
Ⓜ Furio Camillo
Via Tuscolana
Via di Porta Furb.
Via Appia Nuova
Ⓜ Colli Albani
Ⓜ Arco di Travertino
Via Tuscolana

14.2 Porta San Sebastiano

14.3 Catacombs di San Callisto

14.4 Catacombs di Santa Domitilla

14.5 Basilica and Catacombs of San Sebastiano

14.6 Circus and Villa of Maxentius

14.7 Mausoleum of Cecilia Metella

14.8 Complex of Capo di Bove

Tor Fiscale Park

14.1 Park of the Aqueducts

Via Ardeatina
Via dell'Almone
Via Appia Nuova
Via Appia Pignatelli
Via di Grotta Perfetta
Via Appia Antica
Via di Tor Carbone
Viale Erminio Spalla

14.9 Villa of the Quintiles

Walks in Southern Rome

14

Above: Claudius Aqueduct, Park of the Aqueducts, 38-52 A.D.

If you're in Rome for more than a few days and you don't feel like staying in the city, we suggest you spend an afternoon at the Park of the Aqueducts or walking down the Ancient Appian Way.

PARK OF THE AQUEDUCTS

The Park of the Aqueducts > 14.1 is part of the Regional Park of the Appian Way, and it's found in the eastern part of the city. The park extends for more than 240 hectares amongst the Appio Claudio neighborhood, Via delle Capannelle and the railway line Roma-Cassino-Napoli. To get there easily, you can take the Metro A in the direction of Anagnina and get off at Numidio Quadrato; the park will be about 15-minutes away. This way you'll have a chance to cross the Quadraro, a historic popular district, famous for its street art and for having been the symbol of Roman resistance to the Nazi occupation during the war, with internal operations to attack the German forces.

The neighborhood was called a "wasp nest" by the Nazis who besieged it on April 17, 1944 and had about two thousand people arrested, 683 of whom ended up in concentration camps in Germany. The operation went down in history as the Quadraro Roundup.

AMBIENCE

Via Tuscolana is very extended and includes various districts, like **Cinecittà**, where you'll have a chance to see the famous film studios, many of which are open to the public and accessible through pre-booked visits. Other popular districts with a certain charm are **Centocelle** and the neighboring **Torpignattara**. Where you'll find of the best Roman cuisine restaurants, Osteria Bonelli. Always crowded. It is advisable to book before going there, but you won't regret going!

Above: An ancient paved stretch of the Appian Way.

PIT STOP

To refresh yourself after an afternoon spent at the park we strongly advise you to try the nearby *Accassadì* restaurant, in Viale Opita Oppio 70. The restaurant offers typical and carefully prepared dishes of the Roman cuisine. If you happen to take a walk in the surroundings, you will notice how the neighborhood alternates between modern buildings and older ones and sometimes abandoned small houses. These small abandoned houses were part of the old Quadraro neighborhood and can be spotted at the beginning between Via dei Sulpici and Via Selinunte.

From Via Tuscolana, an ancient medieval road that connected Rome to the territory of Tusculum (today's Frascati and Grottaferrata), you can go up Via del Quadraro, where you'll pass the typical local covered market, to arrive at one of the entrances to the large park.

As soon as you get there, it'll feel like going back in time and you'll forget you're in the middle of a city park. In fact, the Park of the Aqueducts, owes its name to the convergence of seven ancient Roman and papal aqueducts, which supplied the city with water and their mighty ruins dominate the landscape.

Seven of the eleven Roman aqueducts met here, the *Claudio and Anio Novus, Iulia and Felice* aqueducts, and then those of the *Tepula, Marcia, Iulia* water and the underground aqueduct of *Anio Vetus*.

Walking through the park, one often comes across flocks of sheep, and, at times, you'll run into film sets. Numerous directors chose to set their films here, including Federico Fellini and Pier Paolo Pasolini who used the park as the set for their movies *La Dolce Vita* and *Mamma Roma*.

The area was transformed into a public park in 1965, but until the 1980s it remained a rather degraded area, with slums and illegal vegetable gardens.

Many displaced people between the 50s and 70s had settled in the area, building illegal settlements between the great arches of the Roman aqueducts, and still today some arches of the Felice Aqueduct in the direction of the adjacent Tor

Fiscale Park bear traces of tiles or plaster, reminiscent of the dwellings that had been built within.

The slum survived until the early 1970s, offering refuge to small gypsy communities and immigrant families arriving from southern Italy in search of fortune. Outside the park, if you go on Via dell'Acquedotto Felice, you'll see the majestic arches of the aqueduct slowly merge with the modern built-up areas, then disappearing in the city traffic.

You'll notice how the wide green area that seems unexplored at times, was converted in a public park only later on and its structure definitely doesn't look like the one of a city park with its alternation of narrow streets, meadows and ruins. One always has the feeling of venturing into new places; the landscape can be romantic, but untamed and adventurous at the same time. In the hot Roman summers, the arches will offer you some shade. The gigantic solitary ruins can only give a glimpse of how majestic Rome was. The mighty arches have served various functions over the centuries aside from their original one: the aqueducts have also been plundered and used as building material and are a perfect example of how everything in Rome has had multiple functions over the centuries, adapting to new eras. This is the charm that reigns in the "eternal city".

ANCIENT APPIAN WAY

Fascinating and definitely well-known is the tour of the ancient **Appian Way**. Called Regina Viarum by the Romans, the road started from **Porta San Sebastiano** > **14.2**, located close to the Baths of Caracalla, to reach Brindisi. It was only completed in 190 B.C., but the first kilometers were started in 312 B.C. Commissioned by the censor Appio Claudio Cieco, the builder of the first

On the top: Mausoleum of Cecilia Metella, I century B.C.

Above: One of the ancient arcades of the roman aqueducts, Park of the Aqueducts.

Above: The Arch of Drusus, part of the ancient Antonian Aqueduct, 9 century B.C.

aqueduct (the Appio aqueduct), who had a pre-existing road that connected Rome to the Colli Albani widened.

The road remained unchanged for many centuries, escaping the building frenzy that animated the city especially during the last century, and originally started from the Tiber Island, crossing the valley of the Circus Maximus to then exit from Porta Capena and walk along the current archaeological walk continuing up to Brindisi.

Even today it remains a very suggestive route, flanked by maritime pines, funerary monuments, ancient marble tombstones, villas and paved with smooth volcanic stones. The archaeological itinerary of the ancient Appian Way runs parallel to the Via Appia Nuova, and it is best done on Sundays, when the road is closed to traffic.

Amongst the famous monuments on the Appia are the **Catacombs of San Callisto** > 14.3, those **of Santa Domitilla** > 14.4, the **Basilica and the Catacombs of San Sebastiano** > 14.5, the **Circus and the Villa of Maxentius** > 14.6, the **Mausoleum of Cecilia Metella** > 14.7, the complex of **Capo di Bove** > 14.8, and the beautiful **Villa of the Quintiles** > 14.9.

The starting point of the route usually coincides with Porta San Sebastiano, which was built on the layout of the ancient Aurelian Walls. Passing under the gate in the dark stands the **Arch of Drusus**, considered for centuries a triumphal arch, in honor of Nero Claudius Drusus Germanicus, a Roman general born in 39 B.C. and relative of Augustus. In reality,

the arch was part of the Antonian Aqueduct, which was built to supply the Baths of Caracalla in 211 A.D. and embellished where it crossed the Appian Way. Curiously, the arch was reused as a counter-door to defend the small, fortified courtyard created and embellished in the Middle Ages using Porta San Sebastiano (275 A.D.). A very similar thing was also done in the nearby Porta San Paolo.
Continuing on the Via Appia we find the **Mausoleum of Cecilia Metella**, one of the most significant monuments of the Roman countryside, in the locality known in antiquity as Capo di Bove from the reliefs of oxen skulls on in the upper part of the Mausoleum. The medieval vicissitudes did not spare the Roman tomb, which today has brick battlements on the upper part as it was fortified in the 9th century by the counts of Tusculum and used as a defensive tower placed along the road.
In the 14th century it was then integrated as part of the Castle, of which we see the remains today. The castle was definitively abandoned in the sixteenth century, becoming a den of brigands who tended to ambush wayfarers asking for a pledge to continue their path.
Porta San Sebastiano and the Mausoleum of Cecilia Metella are just two examples of all the ancient buildings on the Appian Way that had various vicissitudes over the centuries, and are particularly suggestive since the surrounding landscape has not changed much.
The road, conceived as a long straight stretch, remains in an excellent state of conservation which still shows the perfection of Roman engineering. Over the centuries the road has been crossed by emperors, kings and armies. The last was that of the Allies of the V Army, which on 4 June 1944 put an end to the German occupation.

On the top left: The Catacombs of San Callisto, Appian Way, 3rd century.

On the top right: Catacomb of Domitilla, cubicle of the *pistores*, view of the apse with the apostolic college.

Facing, on the top left: The Quintili Villa, on the Appian Way.

Facing, on the top right: Inside the Quintili Villa.

FUN-FACT

When you walk down the Appian Way you'll see **marble stones that indicated the mile** and were used to measure the length of Roman roads which corresponded to 1480 meters in length. Today on the Appian Way there are still some milestones that mark the route. Erroneously attributed to an Anglo-Saxon invention, it actually dates back to ancient Rome.

Map of Rome's Villas and Gardens

- 15.1 Villa Sciarra
- 15.2 Villa Celimontana
- 15.3 Villa Doria Pamphilij
- 15.4 Parco del Colle Oppio
- 15.5 Villa Torlonia
- 15.6 Villa Ada
- 15.7 Vatican Gardens
- 15.8 Japanese Cultural Institute

Points of interest:
- The oldest Nasoni in Rome
- The Tiber in flood
- The Temple of Claudius

Above: Cupid Fountain in Villa Pamphili, marble, travertine, stucco, masonry brickwork, metals, Andrea Busiri Vici, 1855.

Below: Ornamental statues of a Faun and a girl inside the Park of Villa Sciarra.

Parks and Fountains in Rome

15

PARKS OF ROME

Rome extends for over 1200 km and there are almost three million inhabitants in the metropolitan area alone. Although the traffic of the city can be overwhelming, it is by far the city with the largest number of hectares of green spaces in Europe with its 29.38 square kilometers of parks, equal to 67% of the total territory of the municipality.

It is therefore not difficult to get away from the traffic, finding yourself surrounded by nature. Indeed, many parks are surprisingly calm, despite being close to highly frequented areas. In the previous chapters we have mentioned the gardens of Villa Borghese, Giardino degli Aranci, Villa Aldobrandini, the extensive Parco degli Acquedotti, south of the city, and the Appia Antica Archaeological Park. But there are countless other parks in the city center.

Aside from the Botanic Garden in Trastevere you'll also find the beautiful park of **Villa Sciarra** > 15.1. In ancient times the area was occupied by orchards and gardens: in pre-Roman times there was even a sacred forest with a sanctuary dedicated to the nymph Furrina. Afterwards the area became part of the famous green space called "Horti Cesaris", where legend has it that Caesar hosted Cleopatra then bequeathed to the Roman people. The park was then purchased by various nobles during the 16th century and in 1746 was sold to the Barberini family who enlarged the prop-

erty which in the 19th century already occupied the area of the Gianicolo and Monteverde.

Today inside the park are many points of attraction such as the Fontana dei Putti, the Fontana dei Vizi and that of the Fauni. Archaeological finds of the remains of a sanctuary of Syriac deities are also visible.

Not far from the Baths of Caracalla is **Villa Celimontana > 15.2**, a sixteenth-century public park located on the western summit of Colle Celio, one of the seven hills of Rome, very populated during the Roman Republic.

Here are important ancient remains such as those of the monumental Temple of Divo Claudio and today it is occupied by the Park of Villa Celimontana and the Park of San Gregorio al Celio. The first was planned in the sixteenth century by the architects Giovanni and Domenico Fontana and was decorated by Bernini with two fountains, both of which have disappeared.

The Villa underwent an irrepressible decline in the 19th century and was stripped of its valuable pieces, many of which were sold to the Vatican. However, today the garden is extremely fascinating and you can see the remains of the Basilica Hilariana al Celio (2nd century A.D.) which were discovered at the end of the 19th century and were initially commissioned by the pearl merchant Manius Publicius Hilarus, a follower of the cult of Cybele. The monumental entrance of Villa Celimontana is on Via della Navicella and is located near the **Basilica of Santa Maria in Domnica**, one of the first Christian temples in the capital.

In front of the church there is a fountain in the shape of a ship, after which the homonymous Via Navicella takes its

name, sculpted in the sixteenth century by Andrea Sansovino commissioned by Giovanni de' Medici. Inside the park there is an ancient Egyptian obelisk probably from the Temple of Isis and Serapis on the Capitol Hill.
The obelisk was found in the 15th century and remained at the base of the Ara Coeli staircase for a long time until it was moved here in 1820. The third largest public park in Rome is that of **Villa Doria Pamphilj > 15.3**, located between the Gianicolense district and the Municipio XIII. The park originated around the Villa, the country estate of a noble Roman family, and is today the representative seat of the Italian Government. In the park you can totally immerse yourself in nature and it is so rich in plants that it was called "Il Bel Respiro ''(the Wide Breath). Inside there are structures not to be missed like the Casino del Bel Respiro and numerous fountains, including the Fontana del Giglio, symbol of the Pamphilj family and the Fontana delle Lumache.
Another small green lung of the city is located right next to the Colosseum, the so-called **Parco del Colle Oppio > 15.4**, a real "archaeological garden".
Inside are the Pavilion of the *Domus Aurea*, the Baths of Titus and those of Trajan. In Roman times the hill was densely populated but was gradually abandoned in the Middle Ages and replaced by gardens.
In the twentieth century the architect Raffaele De Vico rearranged a part of the garden, enriching it with fountains and a famous Nymphaeum, built by exploiting the unevenness of the land.

Above: Grotesque mask, decorative detail, Vatican Gardens.

On the top left: A glimpse of Saint Peter's dome seen from the Vatican Gardens.

On the top right: One of the fountains that adorn the Vatican Gardens.

Facing, on the top: The Gardens of Villa Pamphili.

Facing, below on the left: Detail of the fresco depicting The theatre of Villa Torlonia, 18th century.

Facing, below on the right: Casetta delle Civette, Giuseppe Jappelli, 1840.

Among the suburban noble villas that have now become public parks, there is **Villa Torlonia** > 15.5. Initially owned by the Pamphilj family, the villa was then purchased by the Colonnas in the eighteenth century and sold to the banker Giovanni Torlonia, who commissioned the construction of the Casino Nobile, the Casino dei Principi and the Scuderie. Today in the splendid gardens, in addition to the Villa and the annexed buildings, you can visit the Theater of Villa Torlonia, the Serra Moresca and the Casina delle Civette, the real attraction of the park.

The latter contains magnificent decorations such as Art Nouveau-stained glass with elements that recall nature in a magical atmosphere full of symbols, from which the personality of its "esoteric" patron shines through. Villa Torlonia also houses the so-called Bunker of Benito Mussolini, who stayed in the villa from 1925 to 1943.

Villa Ada > 15.6, the fourth largest public park in Rome, is on the other hand a magnificent example of an English garden. The park contains neoclassical buildings such as the Palazzina Reale, the Temple of Flora, the Villa Polissena, the Royal Stables, the Swiss Chalet, the Gothic Tower.

Inside the park are also woods of holm oaks, cork oaks, pine forests and meadows. Villa Ada is the ideal park to stop if you are visiting the Trieste district.

Among the most beautiful gardens in Rome are the well-kept **Vatican Gardens** > 15.7, which occupy an area of 57 acres north of the Apostolic Palace.

The gardens follow the Renaissance geometries and are decorated with sculptures, fountains, monuments and botanical gardens; the construction began in 1279 and were designed as a place of relaxation and peace for the pontiff. You can visit them by booking a guided tour through the Vatican Museums website.

An unusual garden in the heart of Rome, a stone's throw from Villa Borghese, is the **Japanese Cultural Institute** > 15.8, open only from Monday to Friday.

Inside the Institute is a fascinating and well-kept Japanese-style garden, created by the well-known architect Ken Nakajima. Spring would be the ideal season to visit the garden, when cherry trees, irises and wisteria are in bloom. It is only possible to access the area upon reservation; all the necessary information can be found on the Institute's website.

ROME AND THE WATER

The strong bond amongst the city of Rome and water has ancient roots. It dates back to the fountation of the city itself on the river Tiber.

In ancient Rome, water was a sacred resource, and the city was the first to have an elaborate water network perfectly channeled towards what would become the metropolis par excellence of the time.

On the top: Gardens of the Japanese Cultural Institute in Rome.

Above: Vatican Gardens.

From 312 B.C. Onwards Rome counted eleven aqueducts that made up the elaborate water system. The amount of water arriving in the city was so big that Strabo wrote "that rivers flowed through the city".

In Rome, water was also synonymous with cleanliness and purification, and it is no coincidence that the city is remembered not only for its glorious thermal baths but also for the small public baths born towards the end of the 3rd century and known only as *balnea*. It was Agrippa who, between 25 and 19 A.D., had the first large private bathing building called Termae built in the Campo Marzio.

The great imperial public ones were twelve and the most extensive were those of Diocletian.

In 19 B.C. Agrippa had the Aqua Virgo inaugurated, an aqueduct that allowed the water supply of the Campo Marzio to the Agrippine baths. Today small traces of the Aqua Virgo cross the streets of the center and the underground ones made up of clearly visible arches immersed in water are musealized and can be visited inside the *"Rinascente"*. After supplying the Campo Marzio, its cycle then ended in the Cloaca Maxima which culminated in the Tiber.

In the Middle Ages, when the city was besieged by the Goths, many of the aqueducts were destroyed by the enemies, to thirst the population, who then descended from the hills and returned to inhabit the center of Rome, using only the water of the Tiber and building fortifications to avoid the enemy settlement. The water of the Tiber was considered drinkable and healthy even in the sixteenth century, so much so that when Pope Clement VII Medici left for a stay in Marseilles

On the top: One of the two fountains of Piazza Farnese.

Above: Fountain of the Books, Pietro Lombardi, 1927.

Above: One of the underground caves under the Temple of Claudius.

Facing, on the top left: Fountain of the Mascherone of Santa Sabina, Piazza Pietro d'Illiria.

Facing, on the top right: Fountain of Clemens XII, Tuscolano district, 16th century.

FUN-FACT

In recent years many applications have been developed to allow the tourist to find and identify the nearest fountain based on her/his location; an ingenious way to help the thirsty but also to make the fountains of Rome better known. Among the famous applications is **Waidy**, the app created in collaboration with Acea, which has digitized 6,000 drinking water delivery points making it possible to identify the closest ones, to learn about their history and the quality of the water supplied.

he brought with him sufficient demijohns of Tiber water until his return to Rome!

In the sixteenth century, water in Rome returned to assume a main role, thanks to the great urban works wanted by the Popes, who built new aqueducts and reused the old ones.

In addition, they gave the city a new splendor, commissioning fountains, bridges, and pools to give glory to their pontificate. In fact, water became the pretext for artists and architects to create beautiful works, which still today make Rome a unique city in the world.

That water is part of the city's charm is evident from its many **fountains** that make gushing clean, fresh water accessible to all. In addition to the historic fountains, the famous "nasoni" were installed in the 19th century, i.e. cylindrical cast iron fountains with a "nose" designed to facilitate the use of water. There are fountains that are not born as such and are the result of a reuse of ancient finds. This is the case of the fountain at the open space of Via degli Straderari, made up of a large basin from the *calidarium* of the ancient **Baths of Nero** found in the 1980s and supported by a Renaissance pedestal. Shortly after on the same street, is the famous Fontana dei Libri, built in honor of the Sapienza University which occupied the building next door, with the head of a deer in the center, the local symbol of Sant'Eustachio.

Another famous case of reuse can be seen in Piazza Farnese, where the two large basins filled with water come from the Baths of Caracalla.

There are also ancient springs that are no longer drinkable today. In Piazza Pietro d'Illiria for example, right next to the **Orange Garden**, against the wall there is a large tub with a mask, recovered from the Foro Vaccino, where it decorated a trough, whose mouth poured the Lancisiana water that stood on the slopes of the Janiculum Hill.

The water was said to have beneficial properties and was called Lancisiana because it was "discovered" by Giovanni Maria Lancisi, physician to Pope Clement XI, who had it channeled towards Porto Leonino. Unfortunately, today the Lancisiana water no longer flows, due to pollution of the aquifer.

In ancient times the fountains were fed by various aqueducts. Among these today are the remains of the Alexandrian one, that dates back to two thousand years ago, when the emperor Alexander Severus decided to renovate the Baths of Nero, where today stands **Palazzo Madama**, connecting them to a long aqueduct that plunges into an underground path.

It is curious to find out which conduits served the different fountains in the city. Today, for example, on the Campidoglio, right in front of the column that supports the *Lupa Capitolina*, there is a fountain with the inscription ACQUA MARCIA. Despite the unpromising plaque written on it (it literally translate as "rotten water"), the water was one of the cleanest and freshest in Rome and came from the Marcio aqueduct, built by the praetor Quintus Marcio Re; at the time it was the longest in the city with its 91 kilometers.

Rome used to be called *Regina Aquarum* (Queen of the Waters), but even today, every year it is supplied with almost 500 million cubic meters of water, coming mostly from protected springs. In fact, underground Rome is very rich in springs and water sources, some of which can be visited, others remain unknown.

The archaeologists and geologists of the **Roma Sotterranea Association** organize guided tours in selected itineraries. If you're not claustrophobic we strongly suggest the visit to the Quarry under the **Temple of Claudius**, which starts from the beautiful **Piazza dei Santi Giovanni e Paolo**, from which you can also see what remains of the ancient colossal temple, framed in between the buildings of the square.

The fascinating underground itinerary leads to the so-called "lakes" of crystalline water, the result of the filling of the aquifer that filled the ancient tunnels of the tuff mines.

Right next to it are the beautiful **Case Romane del Celio**, a very important archaeological site, and as evidence of the various housing stratifications present under the square, that go from the Middle Ages to antiquity. In Rome, there were several professions linked to the distribution of water. In 1661 Pope Alexander VII built the monumental **Fontana dell'acqua Acetosa**, a spring of mineral water described as a source surrounded by greenery near **Piazza del Popolo**, in a pine forest with a small beach nearby used for recreation and breathing healthy air.

In the seventeenth century this water was known for its beneficial properties and was dispensed as a free pharmaceutical for the population to the point that even Goethe praised it.

In the city there were the so-called *acquacetosari*, who took the water directly from the source and sold flasks of the mineral water around the city. Though considered part of the lower echelons of society, the *acquacetosari* fueled this thriving industry for decades. The source of the spring has been abandoned for many years but was recently restored and brought back to its former glory.

A curious fact of nature's reclamation on the urban landscape dates back to 1992, when during the excavation activity for the construction of a large shopping center in the area of the former SNIA Viscosa factory on the Prenestina, the works were abruptly interrupted by the appearance of what today is the only natural bathing lake in the city, Lake Sandro Pertini.

In fact, during the construction of the mall a vein of Acqua Vergine was damaged, which formed a natural basin that is now six meters deep. After many struggles and discussions in 2014 the space finally became a public park with the name of **Parco delle Energie**.

Above: Fountain of Giunone, Piazza delle Quattro Fontane, 16th century, detail.

Index of Places

Ancient Pharmacy of Santa Maria della Scala	26, 29
Appia Antica Archaeological Park	119
Ara Pacis Augustae	54, 55, 56
Arch of Constantine	19
Baldachin of Saint Peter, Gian Lorenzo Bernini	31, 33, 34, 83
Basilica of Maxentius	15, 16
Basilica of Saint Peter in Chains	7, 9, 11
Basilica of San Lorenzo Fuori le Mura	109, 110
Basilica of Sant'Andrea della Valle	69
Basilica of Santa Maria degli Angeli e dei Martiri	43, 44
Basilica of Santa Maria in Domnica	120
Basilica of Santa Maria Sopra Minerva	80, 81
Basilica of Santa Sabina	98, 99
Baths of Caracalla	23, 66, 96, 97, 115, 117, 119, 124
Baths of Diocletian	7, 43
Baths of Nero	124
Bioparco	106
Bocca della Verità (Mouth of Truth)	94, 95
Botanical Garden	25, 122
Campo de' Fiori	67, 68
Capitoline Museums	15, 50, 51
Capitolium Square	19
Casino Borghese	105
Castel Sant'Angelo	53, 83
Cathedral of Saint John Lateran	8, 20
Chigi Chapel, Raphael Sanzio	64, 102
Chiostro del Bramante	64
Church of Saint Adrian al Foro	17
Church of Saint Lorenzo in Miranda	17
Church of Saints Cosma and Damiano	17
Church of San Carlo alle Quattro Fontane	45, 46
Church of Sant'Andrea al Quirinale	46
Church of Sant'Ivo alla Sapienza	64, 65
Church of Santa Cecilia in Trastevere	64
Church of Santa Maria ai Monti	9
Church of Santa Maria del Popolo	101, 102
Church of Santa Maria della Pace	64
Church of Santa Maria della Scala	26, 29
Church of Santa Maria della Vittoria	45, 46
Church of Santa Maria Immacolata	77
Church of Santa Maria in Ara Coeli	49, 51, 121
Church of Santa Maria in Cosmedin	95
Church of Santa Maria in Trastevere	23, 25
Church Santissima Trinità dei Monti	56, 58
Circus Maximus	7, 63, 95, 96, 97, 101, 116
Civic Museum of Zoology	106
Colosseum	4, 15, 16, 17, 18, 19, 20, 21
Domus Aurea	16, 19, 121
Fabricio Bridge	91
Fatebenefratelli Hospital	91
Felice Aqueduct	114, 115
Flaminio Obelisk	96
Fondazione Pastificio Cerere	111
Fontana dei Quattro Fiumi	61, 63
Fontana del Moro	61, 63
Fontana del Nettuno	63
Fontana dell'Acqua Acetosa	125
Fontana della Barcaccia	56, 59
Fontana di Monte Cavallo	46, 47
Forum Boarium	94
Fountain of Acqua Paola	24
Fountain of Aesculapius	103
Fountain of Piazza della Rotonda	85
Fountain of the Acqua Marcia	124
Fountain of the Bees, Gian Lorenzo Bernini	77
Fountain of the Catecumeni	11
Fountain of the Moses	103
Fountain of the Turtles	87
Galleria Borghese	105
Galleria Corsini	25, 26, 29
Galleria Spada	66, 67
GAM, National Gallery of Modern Art	107
Gianicolo Terrace	25
Giardino degli Aranci	93, 97, 119
Giovanni Barracco Museum of Ancient Sculpture	68
Japanese Cultural Institute	122
Jewish Ghetto	79, 87, 88, 89, 93
Largo di Torre Argentina	79, 80, 81
MACRO, Contemporary Art Museum of Rome	111
Mamertine Prison	12, 18
Market of Porta Portese	29
Mausoleum of Cecilia Metella	115, 116, 117
Mithraeum of Circus Maximus	95
Monumental Verano Cemetery	109, 111
Museum of Rescued Art	43, 44

National Academy of the Lincei	25	Piazza della Minerva	80, 81	Temple of Ercole Vincitore	94
National Etruscan Museum of Villa Giulia	105, 106, 107	Piazza delle Cinque Scole	89	Temple of Portuno	94
		Piazza di Spagna	5, 53, 56, 59	The Orangery of Villa Borghese	105
National Roman Museum of Palazzo Massimo	25, 43, 44, 45	Piazza Mattei	87, 88	Tiber Island	91, 116
Palazzo Barberini	16, 26, 73, 74, 77	Piazza Navona	61, 63, 64, 65, 67, 68, 69, 79	Tower of Milizie	13
Palazzo Braschi	68	Piazza Trilussa	23, 25	Trajan Markets	13, 48
Palazzo Colonna	48	Piazza Venezia	15, 43, 48, 79, 101	Trajan's Column	48, 49
Palazzo del Quirinale	46, 47	Pincio promenade	101	Trajan's Forum	13, 15
Palazzo della Cancelleria	68, 69	Ponte Sant'Angelo	53, 91	Trevi Fountain	4, 58, 71, 73
Palazzo delle Cinque Scole	90	Ponte Sisto	23, 25, 91	Triton Fountain, Gian Lorenzo Bernini	75, 95
Palazzo delle Esposizioni	45, 46	Porta del Popolo	102, 103	Vatican City	31
Palazzo Farnese	66, 67	Porta San Sebastiano	115, 116, 117	Vatican Gardens	31, 121, 122
Palazzo Madama	124	Portico dei Leoni	105	Vatican Museums	31, 36, 40, 41, 56, 122
Palazzo Massimo alle Colonne	69	Porticus Octaviae	89	Via dei Fori Imperiali	15, 17
Palazzo Mattei di Giove	88	Raphael's Rooms	36, 37	Via della Conciliazione	31, 32
Palazzo Orsini Pio Righetti	67	Roman Forum	16, 17	Via Tuscolana	113, 114
Palazzo Pamphilj	61	Saint Peter's Basilica	32, 33	Villa Ada	122
Palazzo Savelli Corsini	29, 74, 93	Scuderie del Quirinale	46, 47	Villa Aldobrandini	11, 13, 118
Palazzo Venezia	48, 49	Sistine Chapel, Michelangelo Buonarroti	31, 36, 39, 40	Villa Borghese	71, 75, 77, 103, 113, 114, 119, 122
Pantheon	79, 80, 81, 83, 85	Square of Madonna dei Monti	7, 11	Villa Celimontana	120
Papal Basilica of Santa Maria Maggiore	8, 9, 13	State Archive	65	Villa Doria Pamphilj	121
Parco del Colle Oppio	121	Teatro Argentina	80	Villa Farnesina	25, 26, 73
Parco delle Energie	125	Teatro Marcello	93	Villa Lubin	103
Park of the Aqueducts	5, 113, 114, 115	Tempietto di San Pietro in Montorio	24, 25	Villa Medici	56, 58, 59
Passetto del Biscione	68	Tempio Maggiore	90	Villa Sciarra	119
Piazza Barberini	73, 75, 77	Temple of Aesculapius	103	Villa Torlonia	121, 122
Piazza dei Santi Giovanni e Paolo	124	Temple of Diana	105	Vittoriano	48, 49
Piazza del Popolo	96, 101, 102, 125	Temple of Divo Claudio	120		
Piazza del Quirinale	47				

Printed in Italy